# WHAT
# HEAVEN
## LOOKS LIKE

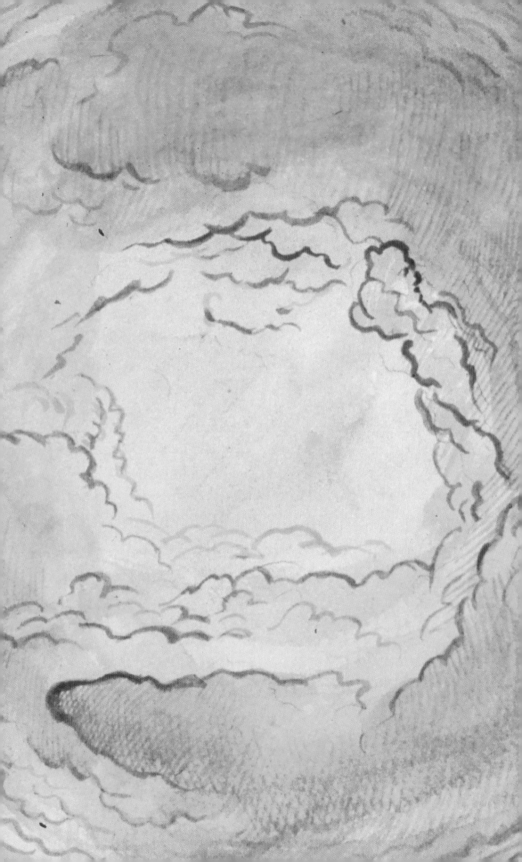

# WHAT
# HEAVEN
## LOOKS LIKE

*Comments*
*on a*
*Strange Wordless*
*Book*

BY
JAMES ELKINS

Laboratory Books
Astoria, Queens

Frontispiece: Detail of plate 6

The paintings in this book are reproduced at a uniform width of 12.7 cm, silhouetted against a white background. Their actual widths vary between 11 and 13 cm.

All images herein are reproduced by permission of the University of Glasgow, with the exception of those on page 9, which are courtesy of Janice McNab.

Laboratory Books LLC
35-19 31st Avenue, No. 4R
Astoria, NY 11106
www.laboratorybooks.xyz

First edition
10 9 8 7 6 5 4 3 2 1

ISBN 978-1-946053-02-2

Library of Congress Control Number: 2017942382

Text set in Adobe Caslon Pro

Printed in the Czech Republic

# CONTENTS

# PREFACE

A woman sits down to her secret work. She lives alone—her husband has died, and her children have grown and moved away. The church lingers in her thoughts, but she is no longer sure what its stories mean. It is the very end of the Renaissance, and the old certainties are gone. Even the myths and legends seem wrong as they drift in and out of her solitary thoughts.

She goes out the back of her house and walks up a slope to a woodpile. She selects a cut log and carries it back to her room. She stands it on the floor next to her chair, and leans over to look at the cut surface. She studies the drops of dew and the damp soft bark. She moves her fingers in gentle circles, following the fine brown rings in the wood. Cracks score the surface like spokes of a wheel. She tests them with her fingernail.

The wood is a lovely picture, made by nature. It means nothing and it says nothing, and yet it is full of faint colors, and, as she looks longer, moving figures. She takes a small sheet of paper and begins to paint.

The book you hold in your hands is a reproduction of a unique manuscript preserved in Scotland. (It's MS Ferguson 115 in the University of Glasgow Library, Special Collections.) The original is just pictures—no words, no explanations. No one knows who painted it, or when. I think it was created by a woman who imagined what she saw in the ends of firewood logs. In one picture the wood is fresh and green, in another old and cracked, in a third moldy and peeling. From this I deduce that she worked at her project over a long period, perhaps years. I think she lived alone, perhaps high up on a forested hillside—at least that is how I imagine her. I have written the commentary in this volume to try to understand what she may have felt and thought.

Her pictures tell a strange and beautiful story of loss and uncertainty. She was deeply unsure about what she could believe. In her mind—an amazing independent mind, as striking in its wordless way as Spinoza's, or Milton's—the culture of community and belief had nearly stopped making sense. She thought hard about the Christian verities, and decided that little is known with any confidence. She was profoundly alienated from the dogmas of her day, and deeply skeptical about some of the largest questions: the origin of the universe, the nature of God, and the possibility of heaven. She mused, too, on the loss of meaning in history and in human relations. I think of her as an irremediably lonely person.

In one sense, she was part of her time: the late seventeenth century saw an unprecedented erosion of faith, and a new awareness of inner life. At the end of my commentary, I have written about the artist's time, and the crises of religion, history, and representation that were in the air.

But in another sense, she is eerily modern. Her doubt and isolation are modern, and so are her paintings. There are things in this book that were not accomplished in art before Surrealism: she plants glassy eyes in dark roots, congeals a patch of air into an amphibious face, turns a ram into a block of ice. Nothing escapes her oddly distorting eye: in one painting God himself is shriveled into a greenish lump.

This is an astonishing, wonderful book. It is ravishingly painted, with a sure, free hand and a mind less burdened by the opinions of authorities than any other I know. It is one of the masterpieces of that half-lost, very modern moment between the faded Renaissance and the overconfident Enlightenment.

*Berkeley, 1996; Galway, 1999; Chicago, 2008–16*

# THE BOOK

It is a small book in a brown binding. It has a title page, and after that there are only pictures—fifty-two of them. They are in watercolor, and they vary in size from eleven to thirteen centimeters in diameter.

There is a little secret about the book, which is not hard to discover: each painting is modeled on the cut section of a tree trunk. Sometimes that fact is hidden, as if it were an embarrassment. (After all, how could a true vision begin from a stump?) In other pictures, the tree trunk is perfectly clear, and the artist has lovingly painted the bark peeling at its edges, or the radial fractures that open when a log begins to dry. Wood is a leitmotif, a thought that keeps recurring. Some pictures are about wood—they show trees, or bushes—and others just use the wood as a springboard for the imagination. The artist never quite decides if the wood is important, and it is not entirely clear whether the paintings could have been based on stones or clouds instead of trees. The artist may have made the entire book from one special tree, carefully conserved as it dried and began to rot. (Some trunks seem to be damp with decay; others look like green wood.) Perhaps the artist went into the forest every morning and cut a new tree, like a Greek priest killing a fresh calf for each prophecy. As a Romantic poet might say, the wood may even have come from a sacred spot—a churchyard or cemetery. One person who saw this manuscript said the artist used petrified wood, on account of the gleaming colors in some pictures. Wood is almost the only secret the book gives away, and in a sense it keeps that secret too.

That is about all that can be said at first look. The paper was made in Holland, toward the end of the seventeenth century. The artist may have lived in that century, or in the beginning of the next: the style tells us as much. But she (I think of the artist as a woman, for reasons I will explain toward the end) could have lived in Italy, France, Holland, or even England. Usually some telltale sign helps identify an anonymous artist: some stylistic quirk, or some figure or composition borrowed from another painting. At least so far, no such clues have broken the manuscript's silence.

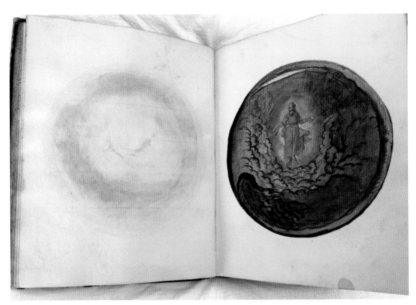

Top: The book closed; dimensions 15.3 × 19.6 cm
Bottom: The book open to plate 19

# THE TITLE PAGE

H ere, in clear Latin script, is the only writing in the book. It says:

*Work of Natural Magic, in which the Miracles of Pneumo-cosmic Nature are Painted with a Brush. Fully engraved by an Ape of Nature, following Nature's universal Catholic Prototype, and dedicated to the eternal memory of the king.*

This kind of title is common enough in mystical and hermetic writing from the end of the sixteenth through the middle of the eighteenth century. Many writers were overwhelmed with the encompassing unity, divinity, and mystery of nature, and felt compelled to try again and again to capture it in words. *Pneuma* is breath, and so the "pneumo-cosmic nature" breathes with the spirit of divinity. "Catholic" and "universal" almost mean the same—that nature is everywhere brimming with holiness.

It's a little odd that the writer says the work is painted, and then immediately afterward says it was engraved, or modeled in relief (the word is *ectypus*). The two don't go together, and they imply that something other than ordinary art making is involved. I like to read the word for "engraving" as if it meant the same as "transcribing": that is, I think the artist meant to underscore the truthfulness of her unprecedented visions.

"Ape of nature" is also unexpected. Apes imitate, and they were often compared to artists, although it was unusual to be quite so forthright about the equation. But people with a mystical turn of mind did sometimes imagine themselves as apes in the larger scheme of the universe.

There are other clues in the title, and more could be drawn out of it. But it is important not to go too far. There is no evidence that the artist wrote the title page, or even knew about it. At least I have a hard time imagining that a person would think of such an unusual experiment (meticulously painting a series of hallucinations in cut tree trunks), one that may never have been repeated up to the present day, and then not want to say more than a few vague and evocative words about nature. In particular, the flourish at the bottom of the page is careless and clumsy in comparison to the exquisite accomplishment of the painted scenes. How could they be by the same person?

Opera
Magiæ Naturalis
Mirabili Naturæ Pneumocios.
a micâ pennicillo Eformata

Per artem Naturæ Simiam
Ad ipsum Naturæ universalis
Cahoticæ Prototypon

in
Totidem Ectypis adumbrata
atqs
Ad perpetuam rej memoriam
Conservata.

# I

ND SO WE BEGIN. The first scene is a landscape, with a city in the distance. It is seen through an opening—but what kind of opening? Stepping back, it resembles clouds, but looking closer it is apparent that the opening is lined with the roots, leaves, and trunks of trees. Or perhaps we are peering out of a cave.

The artist is expert in suspending judgment. Are we looking through opened clouds to a heavenly city? Or out of a cave—where we may have gone to hide, or to pray in solitude—back to the town from which we came? Or through a forest at a distant village? Or even—in the harsh, literal manner so fashionable in current criticism—through a womb, or into one?

Around the outside things get dark, as if to say we are in a hole within a hole, or peering out of one dream and into another. The artist loved these abysses, in which dreams jerk into waking life, or collapse into nightmares. We rarely know where we are, and when there's a foothold, something on the margins is usually waiting to pull us away, or push us back into the deepest recess of a cave within a cave, within a cloud inside a dream.

The city is small in the distance, but it attracts our attention. There is not much to it: outlines of buildings, perhaps city walls and a gate. In front are a few blocklike forms. The clouds are full, and rain may be falling. When I have shown this to other art historians, they have sometimes recognized Giorgione's painting *The Tempest*, which also has a city in the distance, ruins on the left, a grove of trees at the right, and a threatening storm. It is tempting to link this picture to that famous one, but Giorgione's painting was almost forgotten until Romantic viewers rediscovered it in the nineteenth century. Our artist may well have seen other Venetian landscapes and felt an affinity with their half-ruined buildings and deserted pastures.

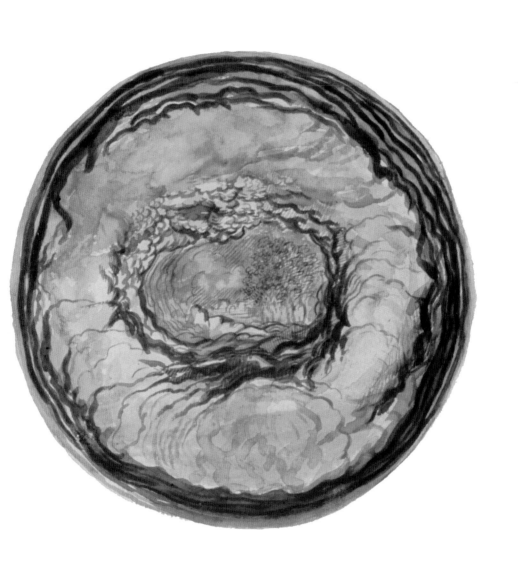

# 2

ONE WORD IS A FRAGMENT; TWO WORDS ARE A STORY. With the second picture we have at least the beginning of a narrative. This is clearly heaven, with two figures reigning in the sky. To any Baroque beholder they would have been God the Father and Jesus. The clouds just below the center are infused with little heads: again something a viewer would have recognized, because painters of the time populated their heavens with little bodiless angels. (They could also be the unstained souls of the unborn.)

At this point it looks like this book may turn out to be a story about heaven and earth, or perhaps a journey from earth into heaven. A viewer at the time might well have found this comforting, since it was conventional to depict the Creation in a series of round paintings. The first painting could be the creation of the earth, and the second a picture of God in heaven, resting after the Creation. It is not exactly what a viewer might have expected (it would be more typical to show the seven days of the Creation, one after another), but close enough to look like a familiar story. Domed church ceilings were painted as apparitions of the heavens, glowing in golden light and banked by clouds, and there are especially famous examples by Correggio that recall the brightness of this painting.

Still, something is not quite right about this heaven. Never before or since has heaven been quite this indistinct. The only way we know which figure is Jesus is that he sits to God's right. The figures have no faces, no hands, and no thrones; they are blurry and distant, like mirages. There is no real sunburst, no heavenly blue. Instead everything is bathed in a sweet midsummer haze, as if the artist were slightly dazzled.

The scene is close to a normal one, but it is unsettling. What is God if he is only a faint orange silhouette in the distance?

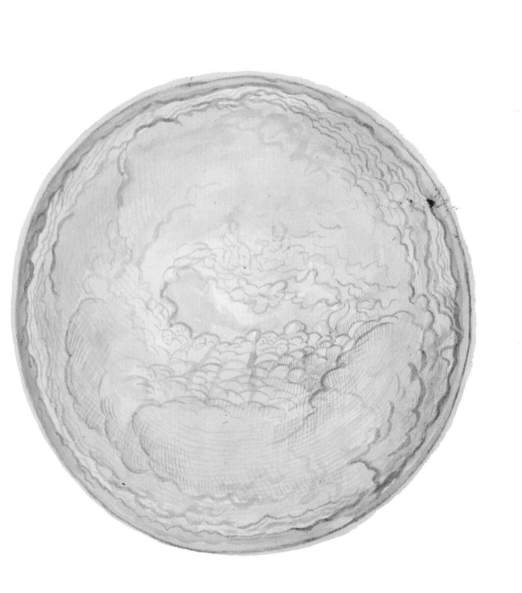

# 3

I N THE THIRD SCENE, something is definitely wrong. The sky is whirl-
ing, and the angels are gone. God—if that's who he is—holds a bolt
of lightning, and other lightning bolts strike all around. On one side
a cloudbank rears up like a wave, and on the other a small tempest is
pouring rain.

When God holds a thunderbolt, he is probably Zeus, and there's a feeling
here that we have passed out of the Christian world and into the pagan. But
who is the other figure? Zeus reigned alone, or with his wife. The second figure
is a surly young man, possibly naked. He almost seems to have a suspicious
expression.

This is the kind of puzzle that delights art historians. It isn't God the Fa-
ther and Jesus, because God doesn't throw lightning. And it isn't Zeus (even
though he has Zeus's tousled hair), because Zeus didn't share his throne with
a naked man. In other artworks there is usually a solution: either the painting
is Christian, or it's not, or it's some comprehensible mixture of the two. In
the late seventeenth century there are paintings of God, and paintings of the
gods, but there are no paintings that might be God *or* the gods, or paintings in
which heaven can be occupied by just anyone.

The artist is in a rare frame of mind: she allows her imagination such free
rein that it wanders against the rules. First it brought her a hazy, enervated
heaven, occupied by a distant Father and Son, and now it's brought her a
strange, possibly heretical heaven, occupied by two vaguely divine men.

The lightning bolts, of course, are radial cracks in the wood. It was cus-
tomary to paint lightning as straight lines (or as zigzags), and so these lines
would have looked like lightning to the artist. But what an interesting deci-
sion, to look only at the cracks and hallucinate everything else.

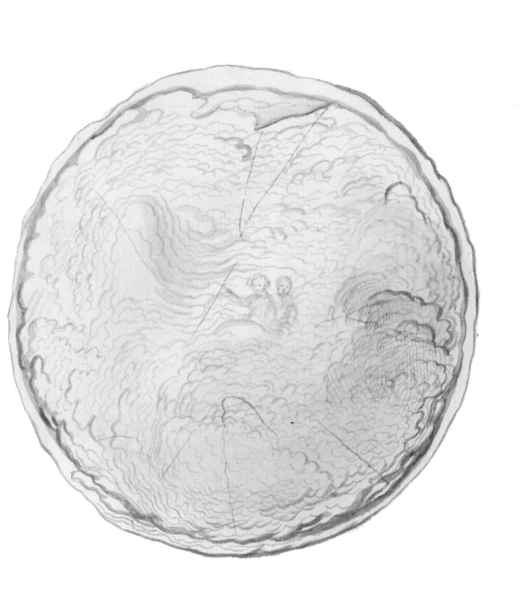

# 4

AND NOW COMES THE PIÈCE DE RÉSISTANCE, the seal of strangeness. At first it looks empty, as if all the divine and semidivine figures have left. Heaven is overcast, and a silvery ring of thickened clouds frames a diminished golden center. The sky is crisscrossed with parallel hatching, which meant rain before and may mean it again here. A curved line—an echo of the lightning bolts in the previous painting—lies across the exact center, and above it the sky is shaded.

If this were merely a deserted heaven, it would complement the deserted earth we saw initially. But it is more than that—very faintly, but definitely, there are still two figures. In reproduction they are especially hard to make out, but on the original there is no doubt.

They are both outlines, painted in a pale olive green different from any other color in the picture. The left-hand form is large and round, and just left of the center. His head—if that is what it is—trails off to the right, crossing the midline of the plate, and then arcs upward and slightly left, forming the outline of a second figure. The companion is tall and gaunt, and leans over toward his friend. They both have heads, but nothing inside, and their bodies trail and merge. In the shadows at their left, there are other wisps of figures—too faint to count, or clearly see.

There is nothing even remotely like this until the twentieth century. (Kandinsky simplified figures in a similar fashion in the 1910s.) It is an amazing, almost inconceivable act of imagination to think of painting such distorted and schematic figures, and to let them stand alone without explanation.

Thinking over these first paintings, a viewer might well decide the artist felt alone in the world. Gods seem to mutate into one another, or evaporate altogether, and so far there are no people at all. Centuries earlier, Epicurus had thought along these lines: The gods, he said, are paper-thin and can do no one any good or harm. People should be kept at a distance, because they cause pain.

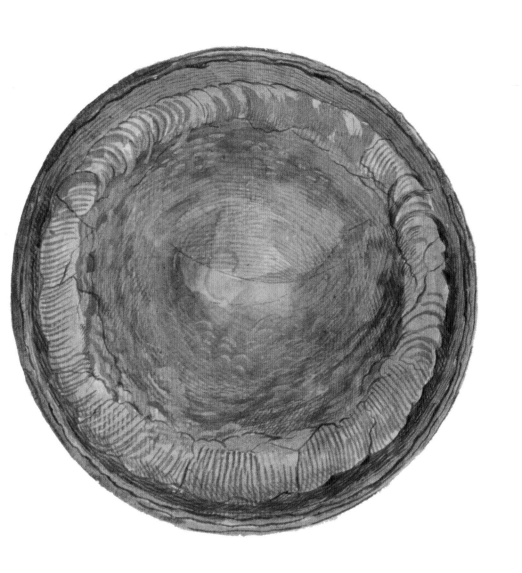

# 5

THEN WE TURN AWAY FROM HEAVEN, and look instead at a blank wall.

It is very dark, and I find myself peering close to the page. Perhaps this is the back wall of a cave, or a place darkened by trees. If it's a cave, it may be the same one we looked out of at the beginning.

Yet it isn't just a wall, it's a niche: a scalloped depression meant to showcase a sculpture. A Baroque viewer would have seen the painting as an incomplete image. It needs a statue: perhaps a bronze faun with his mouth spouting water, or a little marble Hermes or Priapus. But there is nothing.

Fanciful gardens were very popular in this period; some had artificial grottos, and dusky places hidden in woods. People liked to think about deep antiquity, and they made dilapidated temples, little churches overgrown with ivy, and strange sculptures of pagan gods. But they did not make niches and then leave them empty. Baroque gardens were whimsical and romantic; this is bleak.

After a few minutes looking into the darkness, one becomes aware of an enchanting play of light. The rim of the niche is silver blue, and the niche itself shines faintly with a rainbow of colors. On the original (such subtle colors do not reproduce well), the center is a warm peach color, and around it is a halo of pale green, the light tint of a freshly broken sapling.

The colors are reflected from a light source that is somewhere behind us. I assume it is meant to be the setting sun, and that the blue is an echo of the azure sky. If we are in the woods, it is that time a few minutes after sunset when it becomes difficult to see, and the trees around merge into blackness. Or, if we are in the back of a cave, it might be broad daylight outside, and these are the few rays that have penetrated into the last chamber.

This is a sad image, as forlorn as the artist gets. It almost seems to say, There are no people on earth, no gods in heaven, not even any sculpted images that might give us solace.

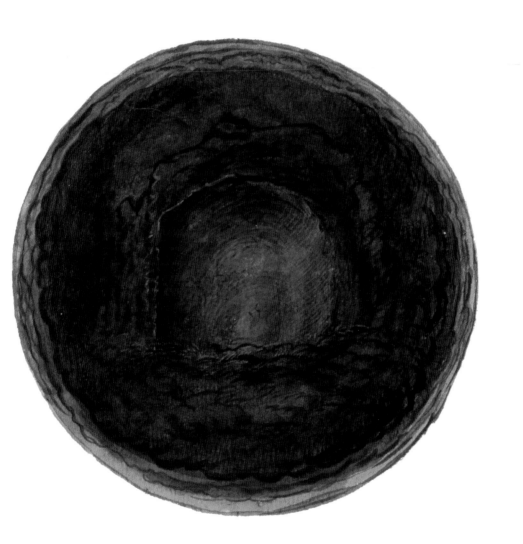

# 6

JUST AT THAT MOMENT, the artist shows a strength that is uncommon in the history of Western art before Modernism: a sense of humor. We look back up to heaven (as you might expect, after peering into the failing light) and find (as you might expect) that it is empty.

Or almost empty: there is a face here, this time not the ominous empty outline of a spectral figure, but a comical face, a kind of joke. I wonder if you can spot it just to the upper right of the central opening, facing away from the light. It is a man, with a broad Roman nose and pinched lips. If he had a torso, it has evaporated. He is so much a part of his cloudy surroundings, in fact, that it doesn't even seem to bother him that two more clouds grow out of his shoulder as if they were about to become extra heads.

When things are this subtle and this unexpected, it may seem as though I am hallucinating or projecting my own fantasies into the pictures. Maybe there is no face here, you might say, or a hundred faces. But there is unequivocally a face in this painting, and only one face. It is painted with the darkest pigment in the picture, so that the eye eventually finds its way there; and it is quite explicit, with its inset chin, pursed lips, high forehead, and coiffure. People who see it tend to start hunting for other figures: one person saw a ghostly dog in the glowing center of the niche in the previous painting, and I once thought the little gray bumps in the fourth painting might be echoes of angels' heads, in attendance on the ghostly pair. This artist is playing with seeing things, and she sees in the most extraordinary ways—but her game is not endless hallucination. I think she wants us to think about seeing things, and she wants us to wonder if we are seeing things. But she can also be very exact about actually placing figures.

This is a painting with a single, entirely surprising and inexplicable figure. He looks like an ordinary person—perhaps even the artist—who has wandered into heaven by mistake. It is empty, and so he is leaving.

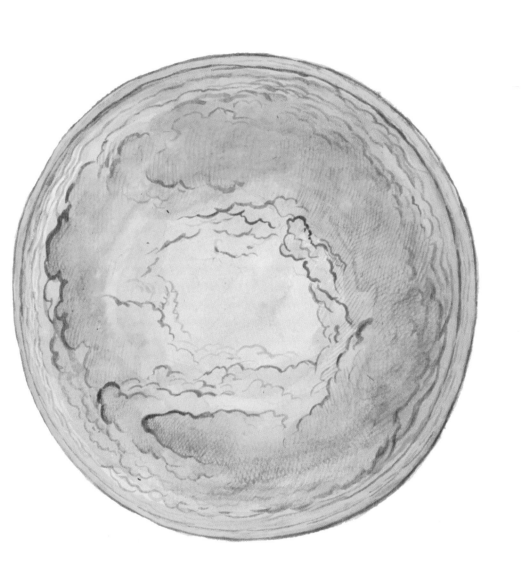

T HAT SEEMS TO BE THE END of the first story about heaven and earth. This plate starts something new: landscapes where interesting events are unfolding.

This is a sulfurous, volcanic place that seems to be on fire. The sky is choked with dusty clouds, and it shimmers with heat like the inside of an oven. Even the earth glows as though it were stoked with embers. In the middle is a heap of rocks, freshly congealed from lava.

In this infernal place—could it be hell?—there stands a holy figure. He has a beard and the mitred hat of a bishop. A man kneels in front of him and crosses his arms on his chest. The bishop is holding something. It may be an open book, but the two pages are canted away from one another, and so they could also be the tablets with the Ten Commandments. The bishop's arms are not in the right position for holding a big book (which would be grasped by the sides, not the bottom), but on the other hand no Catholic bishop should be holding the Ten Commandments. If it were Aaron bowing before Moses, that would make sense, but of course Moses was never a bishop. Through a famous misunderstanding, Moses was often painted as if he had horns, and that may have been the artist's first thought before she turned them into a hat. I take it she wanted the paradox. But what could it mean?

There is no help to be had from the figures at the left. One leans back, recoiling in laughter or astonishment. The other points up into the rocks, and if we follow his gesture, we find people there.

These are very shadowy creatures, the hardest to see of any in the manuscript. One scampers up the hillside away from the man who points. It has a funny hat, perhaps with sharp corners. The others are fused to the rocks themselves. A large figure seems to stand to the left of the fleeing one; it looks headless. Another, vaguer form remains locked in the rock to the right of the fleeing figure. There may be more, but the artist has made sure we cannot see them.

In the library in Glasgow, this book is in a collection of alchemical manuscripts, and the artist does sometimes draw on alchemical themes. This may be such a case: there is a tradition in alchemy of the "planetary mountains," places where the earth produces mercury, sulfur, gold, and the other metals and stones. The planets and the Greek gods were used as symbols of the metals: the planet Jupiter, for instance, stood for tin, and so a picture of a hill with Zeus on top meant the metal tin. Parmigianino, the Mannerist artist, made pictures of such mountains, and this looks a little like his work.

What happens here, though, is much less literal. These are mountain spirits, not gods, and nothing is being explained about metals. This is the "universal Catholic" nature, the world pervaded by inexplicable continuous creation. To understand it, an adept needs knowledge of metals and knowledge of the divine purpose—whether it comes from the Old Testament or the New.

# 8

NOW THE LANDSCAPE HAS SHRUNK, and we are looking at just a bit of it, cut off from the rest like one of the weightless asteroids in *The Little Prince*. Viewers back in the seventeenth or eighteenth century would have thought of cameos and carved gems, and we might think of coins: the figures and their scrap of rock float against a round backdrop, like the embossed head of a coin on its field.

This time the action centers on a boy who is running across the scene and gesturing in a somewhat operatic manner. His pose might well have reminded people of Hermes (who was a messenger and a guide, and so was always running). There were statues of Hermes in more or less this pose, and in paintings his clothes tend to billow the way they do here.

But there is plenty of room for doubt. Although this figure is clearly borrowed from painting or sculpture, it is not as certain that he is Hermes. At the least, Hermes should have wings on his sandals, and normally he also carries his trademark attribute, the caduceus (snakes twined around a staff, the emblem of the medical profession). This boy's cloak flies out in front of him and is caught by a woman, and the two of them together might well have reminded people of Venus and her disobedient son Eros.

Once again, there are two meanings that seem incompatible, and again, they fit together like the front and back of a single coin. If this is Hermes, he represents one of the alchemists' favorite metals, mercury. Mercury was said to be "volatile": it runs everywhere, and even evaporates into thin air. If he is Eros, the same ideas apply: Eros (who stands for sexual desire) is unpredictable: anyone might be the target of his arrow, and he even stung his own mother.

All this makes some sense: it's a meditation on uncertainty, on things that cannot be pinned down, on fleeting thoughts and desires. At least that's what it would be if it were a normal painting. But in this book, it might be something entirely different. This could be just a woman and her son, playing. And it is important not to forget the fat dragon that lies on top of the rock, wagging its big tail and sticking its toothy jaw right in the woman's face.

# 9

THE DRAGON in the previous painting may seem gratuitous, and it makes no sense I can think of. Yet it would slight the artist's achievement to say that she just stocked her paintings with whatever came to mind. The dragon is very deliberately painted. The hatchmarks that go around the plate stop at its tail and resume on the other side. Its body is clearly segmented (like a worm's), and it has a cute little plume at the back of its head. The details are carefully balanced; the dragon's feet, for instance, may once have been more detailed, but the artist has masked them in dark umber tones. I think there was originally a figure to the right of the boy, but whatever was there has been painted out. The scene has all the traits of something that grew slowly and organically in the artist's mind, and was only finished when it reached a pitch of perfection. Even a blatant non sequitur like the overweight dragon has its value. It says, in effect, You will never understand this picture. And that, I think, is a wonderful and deeply modern frame of mind.

Here is an even less comprehensible arrangement, an impression of thoughts even more disturbed. In the middle a gigantic bear holds a tiny man's head in its mouth. They are floating in a swirl of visceral, globular shapes, as if the painting is a view into intestines, and the bear's head and man's head are both being digested by some even larger animal. (Stepping back, it is a gnarled stump or root—but it is always a question of how far back we want to step.)

In the lower right corner a man steps up to a seated figure (probably a woman) and offers her something, or takes her hand. This little vignette would be a love scene, if the woman were a little more real: she is a slightly frightening blur, and she reaches out to the man with long hazy legs—more like a spider perching on its prey than a person shaking hands.

This is a gloomy and threatening painting, and that mood is perfectly congealed in the second bear's head, at the upper left. It has a glassy blue eye, and it seems to brood over the scene with an amused detachment.

# 10

T HE HABIT THIS ARTIST HAS of looking into stumps and finding
fantasies was not original, but other people found stories that were
obvious, and therefore comforting. There was a custom of cutting
stones—especially marble and agate—and finding pictures in
them. For a while in the seventeenth century, it was said that nature some-
times started paintings inside stones but left them unfinished; artists would
cut the stones open, adding figures and reinforcing shapes to make simple
landscapes or mythological scenes. Certain rocks, called "picture agates," were
already so similar to landscapes that they were considered finished paintings.
In the previous century, people had prophesied by finding shapes in deformed
animals and in the gnarls and burls of trees. Nature painted and sculpted, and
people tried to understand what she meant. But in every case the things they
thought she meant were simple: a prognostication of war, a bucolic landscape,
a portrait of the pope. Here all that has been given up, and made to seem
trivial. Nature speaks much less clearly in this book. The artist is looking as
closely as she is able, and setting everything down in its place—but the results
are disquieting, and they often verge on meaninglessness.

This time she sees a figure with a scythe, looking down absentmindedly at
a little boy who clings to him. The man could be Saturn or Father Time—the
two were occasionally interchangeable—but either way he is significantly less
fearsome than usual. (The scythe, after all, is for harvesting souls.) Saturn and
Eros were sometimes paired, and perhaps the artist was thinking abstractedly
about Love and Death. This artist has a sweet, familial streak in her, and she
has soft dreams as well as terrifying ones. Here it's as if Saturn were in retire-
ment, thinking over a day's work—or as if he had become a simple peasant,
whose scythe cut wheat and not people.

The pair are illuminated from behind by a golden light. (Notice the ele-
gant shadow cast by the boy's foot.) In the cloudburst there is an even more
comforting figure, very much the kind that people painted in cut marble. He
is a benevolent old man, possibly also God himself, looking down on his work.
At the left is another old man, gazing out of the scene. All three men look the
same: perhaps the artist was a man after all, and these are three self-portraits,
versions of himself painted on a day when he was thinking more about the
passing years of his own life than the miracles of nature.

# II

I MAGINE THE ARTIST WORKING on these paintings over a fairly long span of time. Each picture would have taken her three or four hours, or effectively an entire day, to paint, and she might well have spent long periods just looking at the trunks, or thinking about how a painting was developing. Do I really see a dragon there? Or is it a man, or a young woman? Nothing is done by rote. This picture may have been especially difficult, because it appears that nature gave her very little. The log was a uniform piece of wood, leaving no room for the imagination.

Naturally, the tree suggested another. A large crack that had developed in the heartwood became the trunk of the painted tree, and the core, which may have begun to darken and rot, became its leaves. Notice the artist's fastidiousness: she does not invent a ground for her painted tree, but follows the cracks that must already have been there, making them roots. A small discoloration below the crack nearly becomes an animal: it gets a face, almost, on the left (a beak, perhaps even an eye), but it never quite comes into existence.

As I picture her working, looking into this stubborn log and not quite seeing anything, I think of what it would be like for most of us to find inspiration in dead wood. The great majority of people see nothing in nature except what is there, and the majority of artists paint more or less realistically: in these terms, they see nothing. Any interesting art, I think, is the product of an engaged imagination that is at least as strong as what it encounters. That is the modern mindset: if nature exists at all, it is a cipher, or a projection, or an opportunity for a display of imaginative force.

Or maybe that's just bluster. This is a beautiful tree, with its white leaves upturned by a gentle breeze. It rests with perfect delicacy on a frail ground and on the faint thought of a dragon. For the moment, the artist's imagination has almost been cleared of its ghosts.

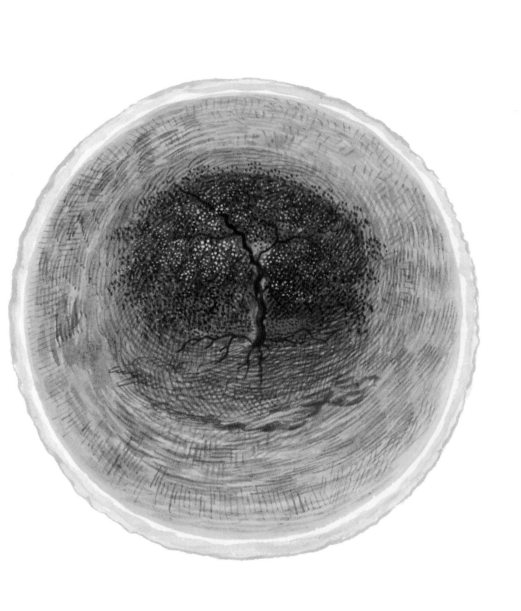

# 12

AND THEN THEY RETURN IN FULL FORCE. On the left are two stock figures of alchemy, both distorted into unique creatures. Snakes, and especially snakes biting their tails, are alchemical symbols of self-destruction and acid corrosion. This one has a typical Baroque beak (both whales and snakes were drawn this way) and a flaccid body. It curls over a chalky figure who may be an unfinished statue, or a person wrapped in a winding sheet. It has no expression, no gender, and no feet. In alchemy such figures are called hermaphrodites, and they denote the half-finished work, when the metals are still unformed. This is an especially strange one, like a natural Galatea turning from peat into chalk, instead of marble into flesh.

As a pair they don't make sense, but at least they have more meaning than the rest of the painting. They are both looking down at a monstrously large frog, as big as a plump hassock. It has bent over backwards so that its white throat and belly are facing upward. There is one small, white, expressionless eye, and a gigantic leg folded underneath. (It has no front legs at all.)

Just that would be enough to make this one of the oddest paintings ever created, but the frog is apparently looking up toward another figure: a big, furry, well-disposed pandalike person with a single cloven hoof who smiles benignly down at the whole mad scene. Alchemists also enlisted frogs, toads, and salamanders in their stable of symbolic animals, and I could say the frog represents the muddy refuse that alchemists treasured for its hidden potential. But no alchemical frog is anything like this obese, puffed-up creature with its incomprehensible gymnastic flip. The panda-person is well outside even the eccentricities of alchemy, and his smug smile has no parallel before Maurice Sendak.

At the center of the painting is a void that shifts and moves with half-seen figures and faces. I think the artist intended it this way: she was being true to her conviction that some figures are rubbery, others chalky, slimy, or furry, and still others made of light. Around the outside of the painting are little perforations that burst with spikes of light, very carefully and slowly painted.

A literal-minded historian could find a meaning for this painting: the hermaphrodite, snake, and frog all allude to alchemy, without getting it quite right, and so they could be reminders of the profound natural process that led to the alchemists' goals of redemption and purity. The fuzzy little faun could—at a big stretch—be the alchemist presiding over the work. Such figures (that is, of more ordinary-looking alchemists) are not unknown. But what a disservice such an interpretation would be. It would throw away the picture's strangeness in the name of some dubious historical precision. The same disaster has befallen Hieronymous Bosch and other artists who use (or misuse) a few arcane symbols.

I find this picture very hard to stomach. It is delightful—at least the frog and the yeti are enchanting—but it is also weird and claustrophobic, with its nearly faceless figure and rubber snake. It has no message, and it is in no mood—at least no mood I have ever had.

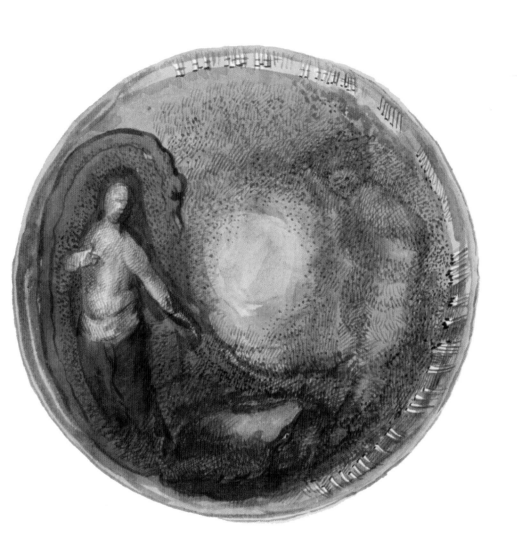

# 13

NOW IT IS VERY LATE TWILIGHT, almost night. In this topsy-turvy world, there is sky at the lower left; to me it looks like late autumn, with a few cold brown clouds scudding past. The sun has recently set. Little shafts of light shine with pale golden rays, like the crepuscular rays that point toward the sun after it sets. In the other direction, at the upper right, it is already full night. It is freezing, and a light snowfall drifts down along the upper-right margin.

This is the time of day best suited for phantoms. A silvery bird glides by on the left, its beak merging with the horizon and its body melting into the shadows. At the lower right another creature passes by: a small, spotted, limbless thing, with a stout head and a tonguelike tail.

A person watches over this lonely scene. His left arm is stretched out, holding a sheep or ram by the scruff of its neck. At the ram's feet there may be another animal sitting, perhaps a sheepdog.

These are just the faintest clues, but they paint a coherent picture: a shepherd, out late at the end of the season, prepares to take the last stragglers of the herd back to their pasture.

Or at least that's what I sometimes find myself thinking, when I need to make some sense of it.

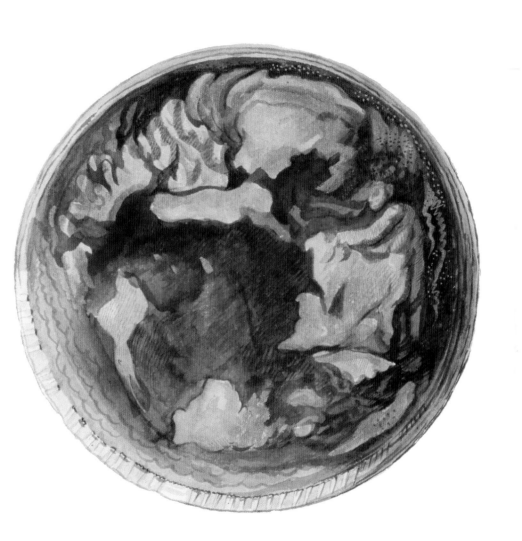

# 14

THIS PAINTING BELONGS WITH THE PREVIOUS ONE and the next one: they form a set of three, probably all taken from the same trunk, and done one after the other in the same frame of mind—slightly lonely, disoriented, and even more open than usual to malformed creatures that slide by on the edge of awareness.

Again it is night, and satin-gray clouds float in a rich umber sky. This second painting is presided over by a bear, which stands sturdily and looks around in our direction. It has two buttonlike ears and a malevolent expression. Like melting icicles, its legs trail off into the warm pool of light at its feet.

An old man is reclining or flying at the bottom. He is not unlike figures of God that were painted in Renaissance Creation scenes, hovering over the dark waters or dividing light from darkness. Or he may represent God drifting through the void of his thoughts before the Creation had begun, although that would be another image unique to this manuscript.

A half-created thing is stretched out at the right. It is silvery, with an amphibian head at each end, and the beginnings of a hand on top. One head looks a bit surprised, and the other glum. The whole remainder of the periphery is occupied by a two-part form, articulated in the middle almost like two legs.

This series of three pictures makes wonderful use of things stretched out around the circumference. Art historians who have looked at them have remarked on their similarity to four other species of distorted round image: early lenses, which were notoriously bad at avoiding distortion; conical anamorphoses, which were donut-shaped paintings that became legible only when viewed in conical mirrors; early microscopes, which were sometimes made of single glass beads and produced fish-eye effects; and convex mirrors, which were often hung in houses and sometimes painted (as, most famously, by Parmigianino).

Each of these types of image has a large literature, and each has something to recommend it. I think the artist must have known one of them, and I'd prefer to think it was the most common one, the ordinary convex household mirror. Wherever she got her ideas about fish-eye effects, she reinvented them in wood. Nothing here comes directly from microscopy, or optics, or anamorphosis, or mirrors. If it did, these pictures could be reconstituted—undistorted—back into some original shape. Anamorphic paintings are nothing but dubious smears until they are properly viewed: then they spring into shape and make perfect sense. But unlike all other Baroque monstrosities, these figures refuse to be reconstituted. They are monsters through and through.

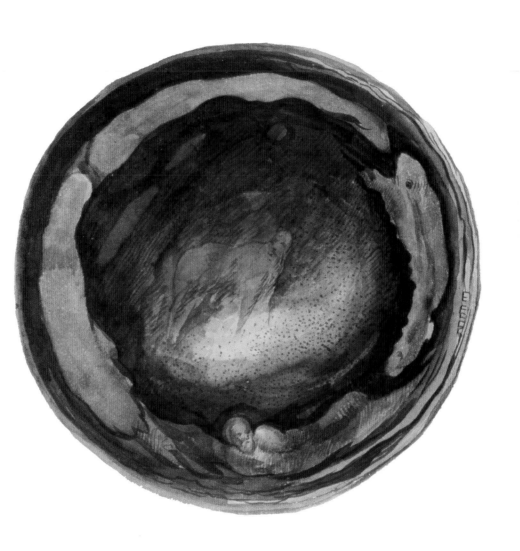

# 15

THE LAST PAINTING OF THE THREE IS THE WEIRDEST and, as we have come to expect, also the most humorous. This artist knows black humors, and also how to escape from them into childish happiness.

At the bottom is a thoroughly childish unicorn, with a Peaceable Kingdom look and a very sturdy horn not at all like the helical narwhal horns that unicorns were normally given. It has a thick pelt like a sheep, and it must be lying down, because it stretches one leg out comfortably in front of itself.

Three birds nestle along the bottom. The one nearest the unicorn is a little owl; it flaps its wings in dismay and looks back at its neighbors. The middle one is another small owl, drawn very simply, like a leaf. The last bird is a tawny pigeon, nestled comfortably in a cranny.

All this simpleminded good humor is necessary because of the outlandish apparition that covers the sky like a purple canopy. It is a lamb: its head is on the right, just back of the unicorn's head, and its hooves are all the way around the other side of the picture, above the pigeon.

I think the artist's regressions are a way of coming to terms with her runaway imagination and its terrors. Here the most drastic distortion calls for the most radical humor: she has painted a puppy dog's face at the very top, right in the middle of the lamb's distended body, like the keystone of an arch. There are no other late seventeenth-century pictures in which cartoonish figures mingle with such accomplished painting—yet another sign of the extraordinary freedom this artist allowed herself. (Even in our day Maurice Sendak did not place his creatures in serious oil paintings.)

This time the light from heaven—a constant throughout the book—forms into a glowing five-pointed star. It is slightly wobbly, like a star a child might draw, but it is also consummately painted, with extremely delicate washes of green, rose, and yellow. It could be the Star of Bethlehem, or the pentagram of witches, or—as I would rather think—a child's star, any star.

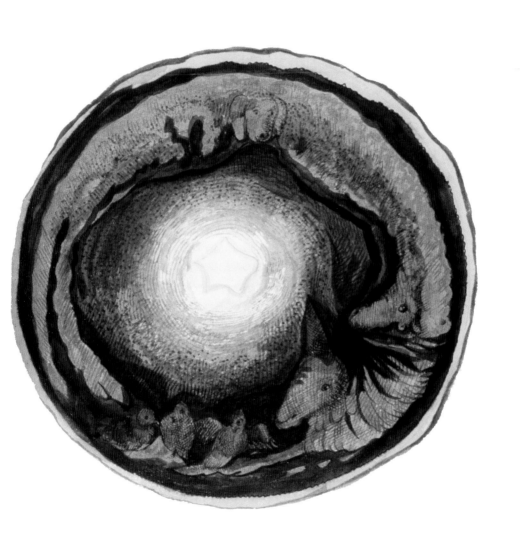

# 16

OCCASIONALLY THIS PAINTER DREAMS OF OBSCURE STORIES that she cannot find in the wood. When that happens, she just paints them as if they were ordinary round paintings, and overlays the bark and grain from the cut sections. The wood nudges the stories a little, prompting her to add details here and there, but mostly the stories are painted on the wood rather than seen in it. In a sense this is not playing the game—but I love that she loves stories without explanations.

This one is almost the biblical story of Tobias, the young man who brought back a miraculous fish from the Tigris to cure his father Tobit's blindness. In the Bible, Tobias is accompanied by an angel, and painters usually show him walking with the fish or applying it to his father's eyes.

But really this isn't the story of Tobias at all. The man who holds the fish (at the far right) is short and old, and the figure who would be the angel (just left of center) has a fat companion (at the far left). This is a meeting between two Oriental figures and two peasants, one of whom has a large fish.

It's like a dream, conflating the story of Tobias with the story of the three Magi. In typical dream logic, one Magus has disappeared, and Tobias and his father greet two angels at once.

Much of this book is dreamlike, and people have proposed that it is a record of the artist's dreams. I am sure the artist was attentive to her dreams: who could produce such paintings without thinking of daydreams, reveries, and hallucinations of all kinds? But most scenes in the book are very exactly observed, and they are the result of protracted meditation on what the wood reveals. As artists know, simple transcriptions of dreams are disappointing—they tend to look hazy and conventional. The stark black band that confines these figures is not what she saw in a dream, but what the wood did to her memory. And I suspect that the little old man who floats there with his fish may even have been suggested by the wood, not by a dream.

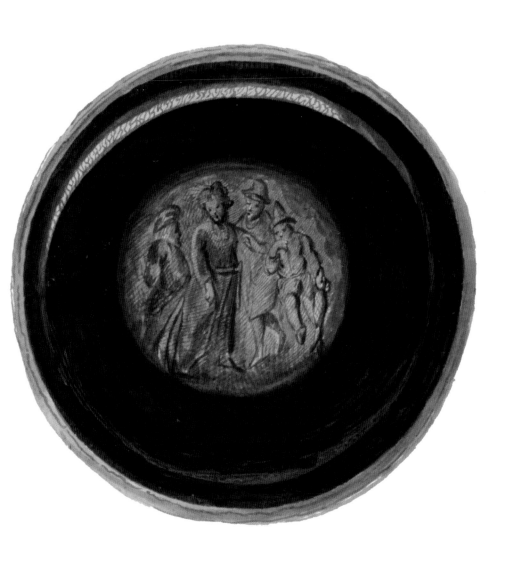

# 17

HAVING SAID THAT, AGAIN I HESITATE. For a person like this artist, spending months and possibly years in an activity so bizarre that it was probably secret even from her family, staring at the cut sections of logs for days on end, letting her visions unfold into shapes and stories utterly unprecedented in their deep irrationality—for such a person, would there be a clear distinction between seeing, thinking, dreaming, and hallucinating?

A crowned lion with a snake in its mouth is a standard alchemical symbol, the most conventional one in this book. It can mean several things, most commonly an advanced stage in the alchemical work, very close to the achievement of the Philosopher's Stone. Needless to say, in alchemical treatises it is never covered with rippling tree rings.

It is just barely conceivable that this artist might have shown her work to fellow alchemists. There are some alchemical books that are little more than long series of round paintings, depicting in symbolical fashion the contents of the alchemist's flask in each successive stage. The shorter series can be helpful for novices, but the longer series (some with as many as eighty pictures) are far too confusing and repetitive ever to yield any insight. If our artist did intend this book as a kind of visual manual (and there were such books, written entirely without explanations or captions), then this would be a bit of firm ground in the quaking bog of uncertainties.

But real alchemical books are very formulaic: kings and queens, swans, tigers, lions, fountains, moons, suns, and chemical symbols come and go in endless alternation. This book is far more rich, willful, free, and circumspect. If it is an alchemical treatise, it is the most obscure one ever written (or, as the alchemists would have said, the deepest, the most profound). I read it more as a diary, a prolonged search for images that might fit the artist's wayward thoughts.

Here, looking deep into a murky pool—or dreaming of looking into one—she sees a crowned lion instead of her own reflection.

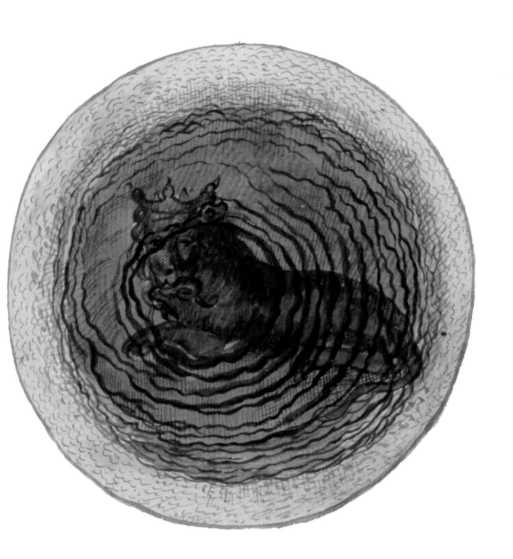

# 18

DREAMS MOVE, but hallucinations, mirages, and objects of meditation stay put. As long as they are before the eye (or the mind's eye), they sit still, as if they were framed pictures or sculptures. An object of constant meditation burns into the retina, and begins to shine with meanings.

Like the previous image, this exceedingly beautiful painting shows us a single object frozen permanently into its wooden matrix. Like a strange insect trapped in amber, it is there whenever we want to peer at it, but it can never be released. To this artist's contemporaries, it would also have looked like a natural wonder, the kind that were collected in curiosity cabinets—a deformed pig, a prehistoric insect, an incomparable fossil.

And what is it? The front half of a lamb, with its legs stretched out as if it is in mid-gallop. In back, its body is captured by sheets of birchbark. The bark casing swathes the lamb's neck, giving it a thick collar, and dangles down under its belly. In back the lamb's body shrivels, and the rolls of birchbark tatter and hang in the air.

Or we could think of it the other way around: a tangle of shredded birchbark rolls itself into a lamb, and the head and legs pop out the front.

This could well be a natural wonder, something to exercise a philosopher or a theologian. It's also possible that this painting would have reminded its maker of an emblem: a puzzling picture like a crowned lion chewing on a snake. Since this wonder was found in the artist's imagination and not in a lump of amber, it is also an emblem of her thoughts.

As an emblem, what does it mean? Surely the lamb is always first and foremost Jesus Christ, the Lamb of God. And wood, in this context, is always the wood of the True Cross. For as long as it is possible to believe that this image is under the artist's control, and that it means only one thing, it is bound to be the mystery of the Incarnation. But that moment does not last long.

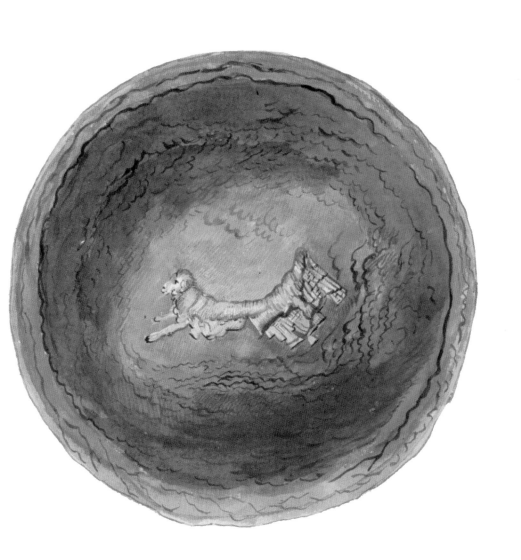

# 19

A T LAST, AN UNMISTAKABLE FIGURE: God. For the first time, the ambiguously open center is filled unambiguously. But where is he? This is probably Chaos, or the turmoil of the first moments of Creation. Possibly God is about to separate the light from the darkness. Here again is a snake, larger and more sinister than before. It cowers before God, and so it must be the Devil. Before the first day of Creation, God had to subjugate evil, and he does that here. The Devil is also—on the hidden, esoteric plane—the alchemical snake, called the ouroboros, symbol of volatility and self-destruction. For an alchemist, Jesus becomes the lodestone, and the snake the uncertain creeping element of life.

The picture has at least these two meanings, both of them strong and almost doctrinaire: first, God struggles with evil; second, the principle of eternity struggles with the principle of transience. Even though the picture is unique (no other painting with these elements is known), its obviousness makes it more ordinary than any other in the book. I take that as a signal that the artist is trying to think something through, and in fact this painting is the first of a series of five that tell her version of the story of Creation.

The snake practically encompasses the picture, or it would if God had not made it snivel. The artist lets its tail deliquesce into the round circumference, so it is not clear just how long it is, but if it stretched itself out and pressed its body into the edge of the painting, its beak would probably touch its tail in a perfect circle—the shape of the ouroboros.

These days there are folktales of snakes holding their tails in their mouths and rolling down hills; they are the docile cousins of the alchemical snake, which actually devours itself, starting with the tip of the tail and ending, impossibly, with its own head. In this scene, the artist toys with the idea: the ouroboros is made to break its vicious circle and melt its body into the background.

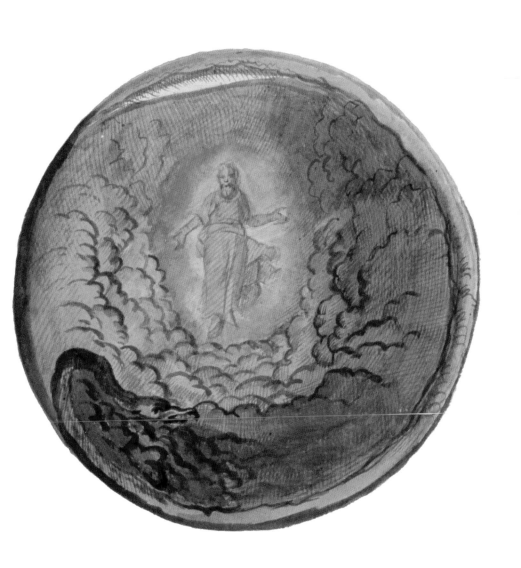

# 20

AFTER THAT PORTENTOUS BEGINNING, we plunge into a deep watery abyss.

The painting makes me gasp for breath: I picture myself at the very bottom of a deep lake, looking up through water choked with ooze. The lake is being slowly stirred, and the waters are roiling around and around, clouding the light. Bubbles leak from decaying vegetable matter, making lazy curving trails as they rise toward the surface.

Or (since the artist loves paradoxes, and a thing may always be something else) I am looking down into a whirling basin of water with spinning walls of mud, as if it were a cup being stirred so fast its contents climb up the sides.

This is the beginning of Creation itself, the most primordial chaos the artist could imagine.

Bubbles are strange enough. (They are yet another innovation by this artist; I do not know of any other paintings of water bubbles before the nineteenth century.) But if we look very closely, we begin to suspect something more: threaded in with the currents, at every level, there are snakes forming. A few suspicious undulations at the top give them away, and one almost swims free at the upper left. Even the trails of bubbles are snakelike: one doubles back on itself, like the snake in the previous painting. Most horribly, if you look closely at the central bluish area—the place where the water is purest—you will see it is laced with tiny brown squiggles: hundreds of baby snakes squirming in the water.

God's creation is making life, and life is threaded with snakes.

# 21

THE SAME PLACE, A MOMENT LATER, and the snakes are growing. Now they are thick as ropes, and they twist around one another, forming clotted vines. "There all the poisons of the heart / Branch and abound like whirling brooks"—lines from a poem. It is clear that in another moment God will have made land and water, and the land will be full of plants; and there will be large trees—like the ones the artist cut and painted—made entirely, every one of them, of snakes.

As every Catholic and every Catholic alchemist knew, the world is full of evil. Its strands are everywhere. This artist's acute visual imagination has brought her to a dark thought that is not in Catholic doctrine or in alchemy: evil takes the form of snakes, snakes are woven into trees, trees are what we must study in order to understand the world. There is a particularly unpleasant kind of madness here.

# 22

IN THE CATHOLIC ACCOUNT, which the artist is trying to follow, what comes next is redemption. To the alchemists and other hermetically minded people of the time, Christianity did not seem quite right, and any real salvation would have to look different than the one in the book of Revelation.

This quizzical angel fills the bill: he is bearded, like Jesus, and he has just the trace of a crown of thorns. But Jesus never came flying to earth on wings, and angels do not have beards.

At the time there were some esoteric hybrid creatures that the artist may have had in mind: the bearded "Jesus" dressed in women's clothing, worshiped in several towns in Europe; the hermaphroditic cross between Jesus and Hermes who guided alchemists and wore a beard and a dress; and Apollyon, the bearded angel. Each of them was an attempt, made with the most intense devotion, to adjust Jesus so that he could be believable.

This cold, silvery, bearded, armless angel must have stood for salvation, at least in the artist's eyes. She lets the radial lines of the wood provide his splendor: in fact, looking at the original cut trunk, she must have seen nothing but the splendor and improvised a god to fill it.

He flies down, toward the dark ruined earth. All around, there is the suggestion of an undulating ouroboros. And we, the viewers of this picture, are buried inside the snake-filled earth.

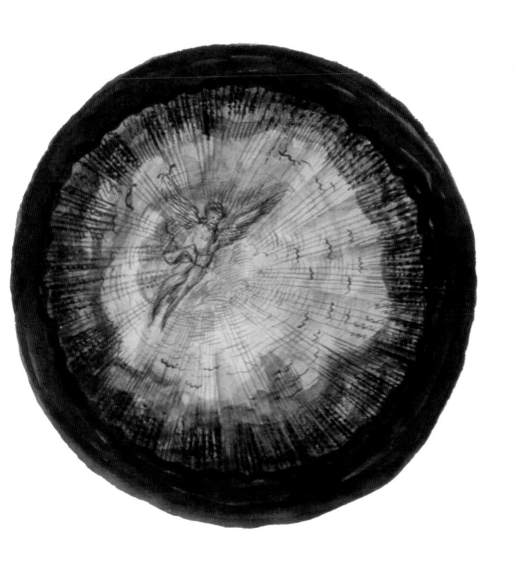

# 23

THE FINAL SCENES OF THE STORY OF CREATION are the Last Judgment and Second Coming. The artist does not give us that—she may have felt unsure about it. Instead we witness a vast crowd, the only one in this book where most places are empty or nearly so. It is a titanic battle, seething with figures. A soldier stands at the top, dressed in a red uniform, a sword, a sash, and a tall hat with a greenish feather. He brandishes a cat-o'-nine-tails, threatening to whip the crowd. A large dark figure stands off to the left; he is strangely hard to make out.

Apparently the crowd is coming over the crest of a hill, since the artist has painted dozens of flesh-colored spots at the top to indicate faces receding into the distance. As they come upon the helmeted figure, they fall. One figure is especially clear, plummeting down with his back to us. To his left, a woman begs at the soldier's feet. The rest of the people have settled into a crowd. Using computer enhancement it is possible to discern eight figures, lying, standing, or sitting. No one is being tortured, and only the one figure is falling.

This is the Fall of the Rebel Angels, when Gabriel, in military dress, helped push Satan and his army into hell. The strange dark figure at the left, who remains indecipherable even with the help of the computer, must be Satan. Why does the artist think of the fall of Satan just after redemption? Perhaps redemption was only a pale hope, and her mind is drawn back to evil. The book is full of falling: we look up from underground at the sparkling angel, up through muddy waters at a filter of snakes, out through the mouth of a cave to a sad little village. We look up, along with Satan's allies, from hell. We are buried, drowned, entangled in roots and serpents.

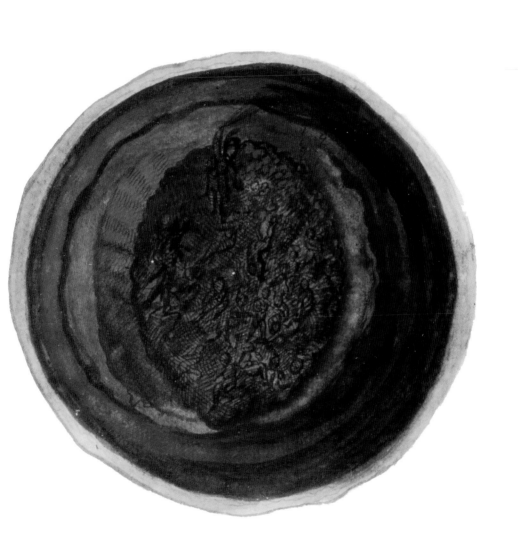

# 24

THE EFFORT OF THINKING SO HARD ABOUT CREATION, sin, and redemption has exhausted the artist, and from here on she begins to meander among more personal memories. How much can any of us bear to think about the end of time, or the beginning of the universe? The second half of the book is a record of a very rich inner life: these are the scenes and fleeting visions of a person who kept her own company, and had no need of the barrage of images we ingest from television, movies, and advertisements.

Her thoughts often return to this place in particular: it is a quiet corner of a garden, where a small bench has been set against a hedge. The plants, left untended, have grown up into a soft thicket. A thin young man is sitting on the bench, naked except for a trailing piece of fabric that he holds in his lap. He has just turned and seen us, and his right hand curls in toward his chest in surprise. A little boy leans over the top of a bush; he may be half asleep.

This could be a dream or even a fantasy (finding a handsome young man alone in a garden), but the artist has dressed the two figures as apparitions. The man is also spiritlike: he is bald and impossibly thin, and he has a woman's thighs and tapering ankles. The little boy resembles an attending angel, and he crosses his arms in a gesture of love and despair that artists usually reserved for angels crying over the dead Jesus. And the odd curve of that right arm: sometimes I see it not as an arm but a snake, curling around from behind and biting his breast—or suckling from it. A huge warty ouroboros encircles the scene, and for the first time in the book the artist lets it bite its tail.

Before modern culture got underway, spirits were often as real as ordinary people. These days we would say that the artist remembered this place, and perhaps even these people, and then doctored them to look like angels. But why not the other way around? These may be spirits she knew, and she undressed them to look more like people.

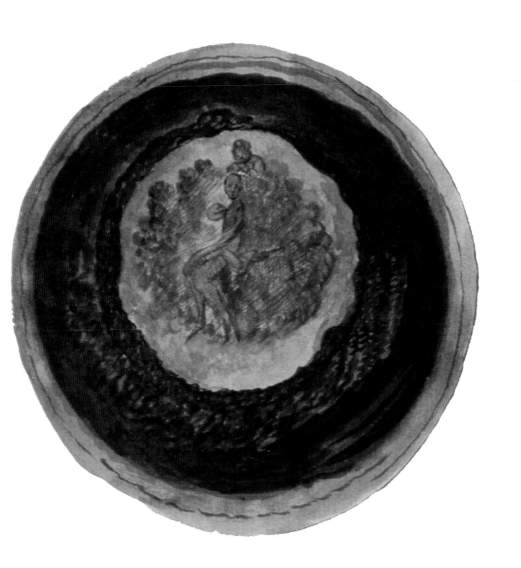

# 25

THIS ARTIST IS UNIQUE, ALONE IN HER PERIOD. She does dozens of things that no other Baroque artist thought (or dared) to do: she plays with the pivotal figures of Catholic dogma; she erases God; she paints stories that make no sense; she pulls lambs into clouds and clouds into salamanders; she imagines obese frogs that turn upside down; she paints the lonely and inexplicable images of her dreams.

She is also unafraid of abstraction, a possibility most artists shied away from until the late nineteenth century. This painting is another golden heaven, an image that comes naturally to her mind, and, like the pictures at the beginning of the book, it is crossed by lightning. This time, though, it is finally entirely empty. (At first she couldn't bear to think of heaven without some occupants.) Nor does she care that her sky does not look like air or clouds—in fact, it looks more like the pelt of some short-haired animal. This is not a heaven you might see by lying on your back in a meadow or craning your neck looking at a painted ceiling, or even a heaven that might unfold in a dream. It is idiosyncratic, and close to pure abstraction.

There are certainly ghosts present. The edges are crowded with shadows, like the figures that perch on cornices in Baroque painted ceilings. At the right a congregation of ghosts is arranged with the studied tilt and disorder that Tiepolo enjoyed, and that part of the painting is like the shadows cast by one of Tiepolo's groups on some higher ceiling. At the left are curtainlike forms, echoing the swags and hanging draperies in ceiling paintings; and at the bottom is a wavelike ornament reminiscent of the seashell shapes popular in Baroque paintings and jewelry.

But there is a gulf between this image and a happy ceiling by Tiepolo. His paintings have real figures, with turbans, tablets, and ermine robes, and they play their parts in allegories of kingship and geography. This picture is only a husk. The artist resists drawing real figures, or even settling what she has in mind. It is breathtaking to watch her dare to refuse to make sense.

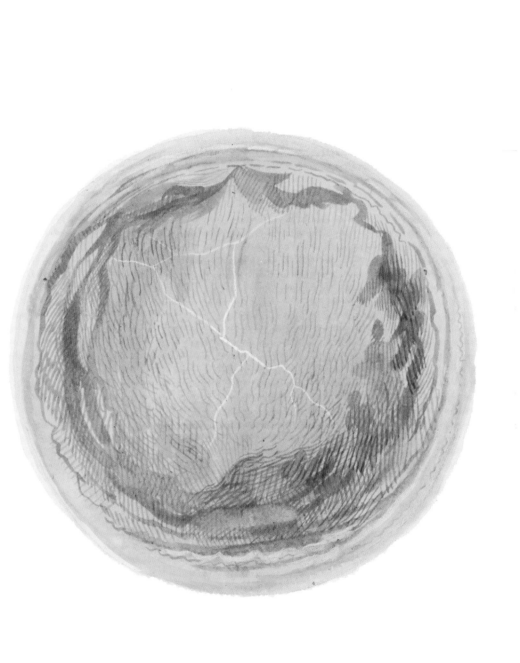

# 26

A MISSHAPEN BOAR, with the body of a prize bull, the ratcheted beak of a bird, the horned temples of a toad, and the jowls of an old man. It has a thick, gelatinous tongue—or else it is holding an egg or a fruit. The eye is attentive, but ringed with lines of exhaustion and age.

Behind it two peasant boys converse. One turns to his friend, who is seemingly about to pat the boar, or grab hold of it. This could be any farmyard scene, and there were painters at the end of the seventeenth century who specialized in such subjects. They especially relished the muck of farmyards, and the tattered greasy clothes of country people. If it were not for the oddity of this boar, with its nearly human expression, this could be one of their dank farm paintings.

But the boar's acute expression (and its jaw, slackened in astonishment) direct our attention to the patch of sky just in front of it. Something definitely seems amiss. A thin, curved line leads from the boar's right ear up into the air, and toward the rim of the picture. In front of the boar's throat, a dull shadow seems to mark the bottom of something.

This puff of air may be a creature, pressed up against the boar's face like the neighboring piece of a jigsaw puzzle. Unmistakably, there is an eye in that patch of air, floating several inches above the boar's eye. A second eye may be off to the left. The artist seems less sure of herself than usual: I think she painted the one eye and then recoiled from the thought, because it makes a jellied head, with swollen lips that suck on the boar's beak. It is a monster in what we now somewhat abstractly call "negative space," and this may well be a moment when her nerve gave out.

Or maybe it's not that gruesome after all. Maybe the boar just looks up, startled, into empty air, like Goya's unsettling painting of a dog barking at an orange sky.

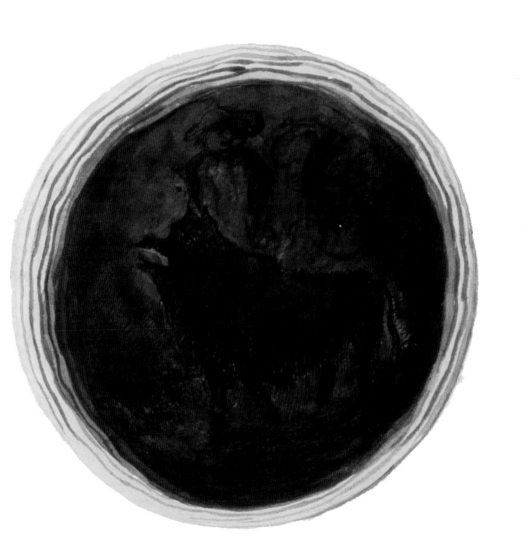

# 27

T<small>HIS IS A VERSION OF THE BIRCHBARK LAMB</small> (plate 18). It is an unmoving image, this time cold and greenish gray.

The creature at the center defies description. Literally speaking, it is a foliated crack in the wood, painted as if it were a crystalline inclusion spreading its mineral wings into the crevices of a rock. It has the formulaic look of a coat of arms; its left half recalls the way a lion or some more exotic heraldic beast rears on its hind legs and waves its paw. To an alchemist it would have also suggested a phoenix, the bird that rose from the charred ashes of its burnt nest. And it looks very like a disheveled insect trapped in amber.

Whatever it is (and I think the artist has left it perched undecidably between several alternatives), it has pride of place in the image. It is set in the middle of a round island surrounded by a ring of water, which is encircled by a hemp rope and narrow bands of light green, yellow, and brown.

Several paintings in this book are close to a kind of Renaissance and Baroque map that shows the universe as a series of concentric circles. Such maps look like polychrome dart boards: the earth is in the middle (with the Garden of Eden at the exact center), and then come the ocean, the sky, the planets and the sun, the fixed stars, and finally heaven itself with its angels.

The island earth, the encircling ocean, the rings, and even the rope can all be found in such maps. But what could it mean to put a fossil in the Garden of Eden? Is this a desiccated Adam and Eve? And why is the earth deserted?

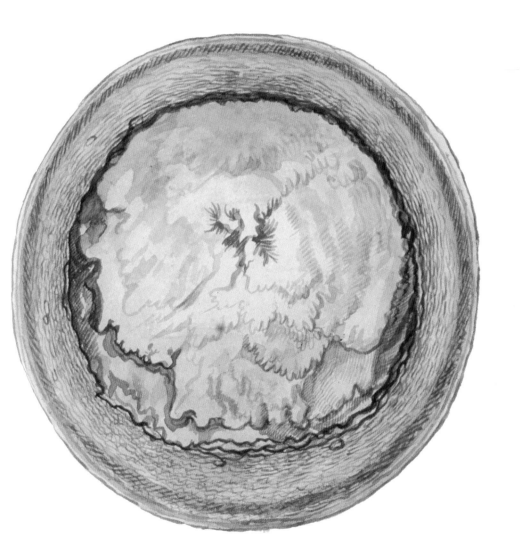

# 28

AN OLD CONVEX MIRROR, CRACKED AND DUSTY. Or an old crystal hemisphere, or glass earring. Or bottle-glass windowpane.

It's hard to know just what the substance is, but we can tell that it's glassy from the smeary reflections across the middle. Within it, like another ambered insect, is a diminutive face, lost and off-center. He's a young dandy with a smug but friendly expression, wearing a whimsical fur hat planted with two plumes. His face is rudely cut across by a crack—although the cracks are also three-dimensional, so that, up close, the dandy looks trapped in a web of roots.

Over and over the artist discovers ways of making pictures that otherwise had to wait until the twentieth century. This is the only portrait I know before Giacometti in which the sitter is so tiny in the frame. As always, it is the wood that prompts the artist: if you squint at these paintings, they reveal what the cut sections must have looked like before they were lavished with such close attention. This one had a flaw: an old knot swallowed by later growth, or a rotted cavity. It had the shape of a profile head with a curl on top, and so she fitted it with the dandy and his hat. That was the easy part. Afterward, she did what no artist for the next two hundred years was willing to do: she just left the painting as it was.

If this had been an object in a curiosity cabinet, the caption might have read, "Small profile head in crystal." Now we know better how to respond to such pictures: the dandy is pathetic because he has drifted from his proper mooring in the center of the picture, and that gives him a sadness and makes us think he may be only a fading memory. Surely the artist knew that as soon as she painted him, but she did nothing to correct it. She let him rest in his dusty glass bowl. Other painters, especially the sophisticated and intellectual natural philosophers at the court of Rudolph II (where late Mannerist art was produced, alchemy was practiced, and curiosities were gathered) would have found a label and an explanation. This artist was much braver, and more faithful to what she saw and how it made her feel.

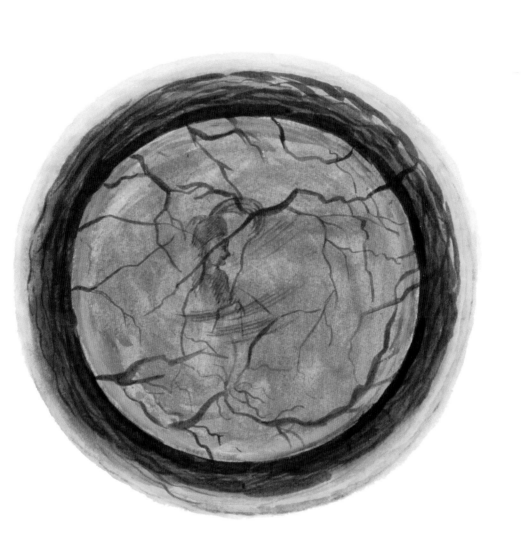

# 29

THIS IS THE SIMPLEST OF ALL THE PAINTINGS. A young man sits on the ground, staring into the distance. He wears a tight-fitting jacket and pants. It is a clear summer afternoon, and a breeze is blowing. A moment ago he was thinking, his hand on his head; now something has occurred to him—an errand he has to do, someone he has to meet—and his hand remains upraised.

He is not in the secluded garden corner where we last met him, though: his piece of turf has literally risen up into the sky, where it floats weightless above the world. Perhaps he sees the whole earth, with its dark hills and meadows, or perhaps he only thinks of them.

It is a picture of deep well-being and equally deep isolation.

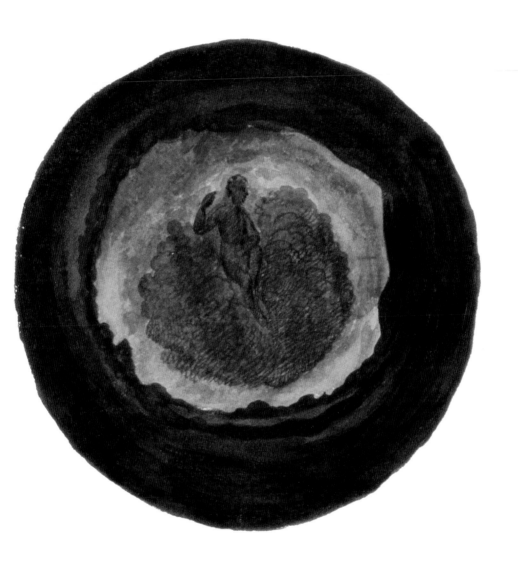

# 30

THIS IS A COMEDY, BASED ON A BAWDY CLASSICAL THEME. Three women in the mouth of a cave watch three men showing off outside. The men cavort dramatically, and the women pose coyly.

The men are dressed as famous Greek heroes. On the right is Hermes, this time in full regalia with his winged cap, winged shoes, and caduceus. He strikes an appropriate pose to show his swiftness, but he's a tubby fellow and seems in danger of falling over. In the middle is Hercules, brandishing his club and showing off his muscles. At the left is a truly sympathetic figure: probably the hard-working Atlas, holding up the world. (He may also be Hephaestus, the crippled blacksmith, or even Sisyphus with his boulder.) All three are really middle-aged men playing as gods, and the artist has put them in costume the way that Velázquez and Callot dressed up peasants and called them Mars or Venus. The three are quite a sight, and they are all naked. (The man playing Atlas may have an erection—a typical low-comedy detail).

The women are delighted. The one in the middle puts her hands behind her back and prances seductively into the cave. The one on the right turns her head away, flipping her plaits in the air. And the one on the left—well, she's a dog, so she can't do much. Her immense, bloated head just sits there, and her long ears flop backward in dismay. She watches her companions with her big black donkey eyes. Even if she wanted to stand, she probably couldn't, because her legs—like those of the other girls—are spindly deer's legs, with dainty pointed hooves.

In short, this is a salacious lowbrow sex comedy like something from Apuleius's *Golden Ass*. Everyone is playing, and no one is serious, although there may be some witchcraft afoot. (That woman may turn out to be a *real* donkey.) Assuming as I do that the artist was a woman, it is to be expected that we see all this from the women's point of view. The men are on display; the women are doing the looking.

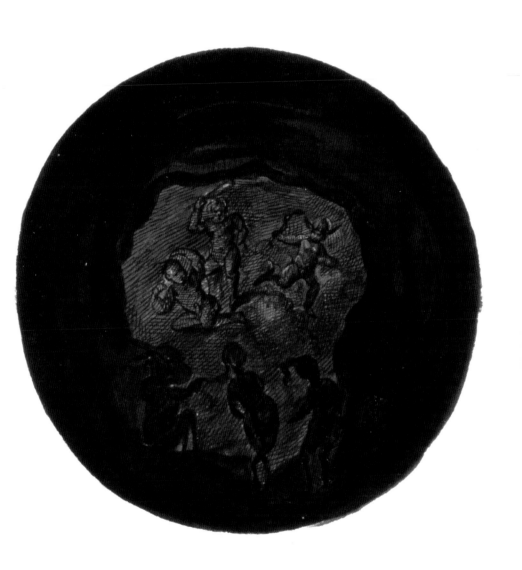

# 31

THERE IS HARDLY A MOMENT TO RELISH THE COMEDY before we are plunged into a world more alien than anything we imagined possible.

An undulating valley cradles a disembodied head, like an egg in an eggcup. Off to one side, embedded in a watery hillside, a swaddled child looks on and smiles faintly. He is wan and perhaps sickly, and his smile looks insincere or a bit desperate.

The big head seems dull and harmless: perhaps it's befuddled or slightly dimwitted. It has a drinker's red nose and a puppy's lips. If you look only at this head, the image may almost seem comforting and placid. But look anywhere else and it turns sour, like a dream where everything begins to seem ominous. The big head has a floppy hairdo that springs up on each side like a dog's ears. But on closer inspection the hair is continuous with a reddish bulge on the horizon. Some people who have seen this picture think the bulge is the setting sun, but if the hair continues on backward, the bulge might be an engorged body, swelling up behind the head. The big head may be the front end of another legless, armless larva, this one lying on its belly.

There is no way to decide where the two larvae are. The landscape may be a dry valley, or one of the sloshing ocean coves so beloved of seventeenth-century Neapolitan painters. If it is water, the little round white forms might be other larvae carried along by the current. Water or rock, it frays at the right, and unravels into hair.

A millipede makes its way across the lower margin, its hundred legs moving in a sinuous rhythm. Perhaps the infant is looking affectionately at it. A stain also crosses the scene, passing invisibly through the big head and swelling into another ghostly larva that hovers between the two others.

What words could possibly describe this scene of idiotic paralysis? It is a prodigious picture, with a pummeling strangeness that is enough to put the Surrealists to shame. In the end, of course, no explanation will do. It is just a silent universe where little pupae with almost-human faces rest quietly, some on their stomachs and some propped up. Occasionally they exchange sweet, empty smiles.

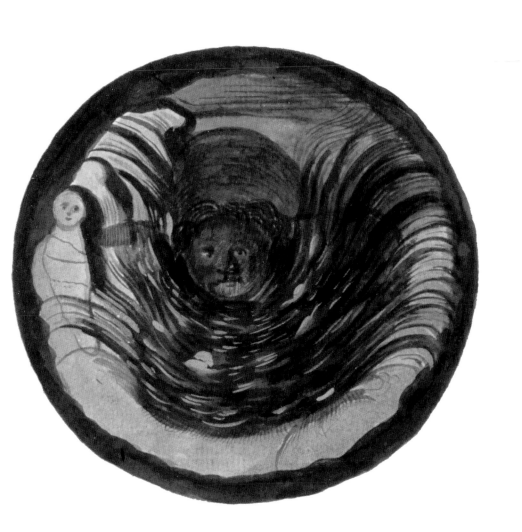

# 32

ALL OF A SUDDEN, AFTER ALL THESE JOURNEYS into myth, theology, and dreams, we are face to face with dinner guests.

They are dressed in the fashion of the times (the late seventeenth century): the man has a well-cut jacket that shows off his ample figure, and he has topped it off with a silvery cravat and a puffed velvet hat.

The woman—his wife, we imagine—stands stiff and formal, holding up her dress so she can step forward when she is invited.

And what, exactly, are they going to step into? It seems like a cave, the same one we have been inhabiting since the very beginning. It looks damp, and it is ringed with suspicious roots.

It is not easy to decide if people like these were the artist's equals in society, or her idea of aristocrats. Her watercolor technique is impeccable, and shows a hand trained either in an academy or in a major workshop. This painting in particular betrays a kind of fluency that is also appropriate for etching, and in other pictures she uses double and triple hatching in an extremely skilled manner, implying several years of formal training. But neither the academy nor the workshop was a guarantee of social standing, and workshops in particular turned out ferociously uneducated people. If she was an alchemist (and women alchemists were common), she might have trained with someone who had a university education; but then again she might not. There were also many ignorant alchemists, and her symbols could be interpreted either as the products of profound learning or as the obvious choices that would have been known to most any outsider. I prefer to think of her as a proletarian painter, friend and disciple to alchemists: a professional artist, and a dabbler in alchemy, natural philosophy, heretical thoughts, and Catholic mysticism. The peasants and young men were her equals; these were her patrons.

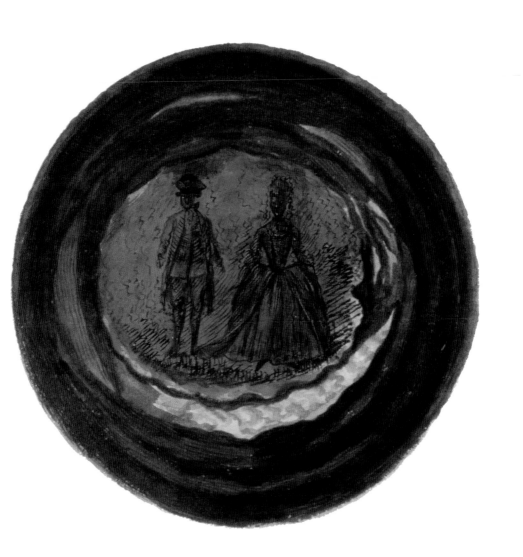

# 33

IN THE BAROQUE, IT WAS PERMITTED to play with pagan themes, as long as they did not interrupt serious Christian piety. A number of artists tried their hands at invented idolatries, and this is another almost light-hearted attempt along those lines.

Two young men dance around a herm that has a butterfly-shaped helmet and a trapezoidal beard. (Together the beard and winged helmet look like three arms of a Maltese cross.) A solitary figure sits on a curved sculpture (perhaps a sundial) and prepares to play his shepherd's flute. That much is typical.

In front, however, two men gesticulate wildly around a picture. One wears a pointy hat, a long cloak, and a codpiece. He has fallen to one knee; as he unfurls the picture, he also points off to one side, and almost tips over. The other man wears a turban and a padded jacket. He seems to be sitting, but his seat is tilted nearly forty-five degrees, and he is also about to slip. He throws out his arms, either to balance himself, or in astonishment at seeing the picture. The picture itself is a nondescript portrait of a man.

No other painting I know has two men admiring a picture in front of an outdoor pagan festival. It's all a bit dreamlike, as if in classical antiquity people had only two things to do—worship dubious gods and haggle over pictures.

The bucolic scene is watched over by a huge worm with a diffuse, ragged face. Another segmented worm creeps up the other side of the picture. (For this artist, snakes and worms are nearly the same: one has a beak, and the other undulates like an earthworm or a tapeworm.) It would be easy to see these snakelike worms as emblems of the Catholic sense of evil, lurking in dirt and turbid water, and swelling up whenever things seem too carefree.

But happily this artist can throw off any interpretation. Stuck up above the bigger worm is another of her exhilaratingly incomprehensible objects. Is it two marshmallow eyes, staring over the rim of the world like Kilroy peering over a wall? Or two snowy breasts with black nipples? Like a twentieth-century artist, she is adept at erasing meanings: first this was a pagan festival, then a story about the art market, then an allegory of sin—and now what is it, watched over by these two ludicrous eyes?

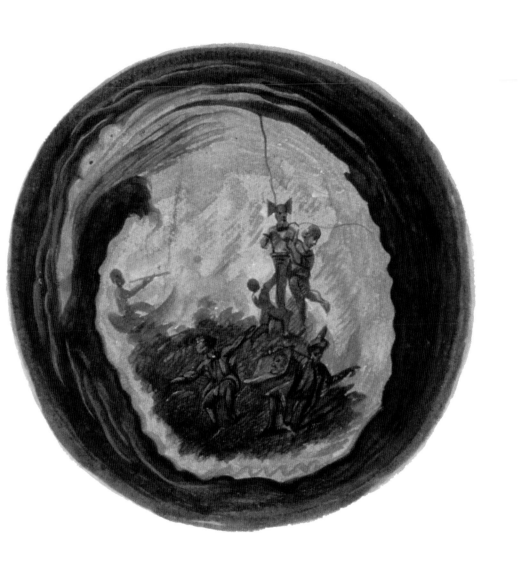

# 34

THE LINEAMENTS OF THE ARTIST'S IMAGINATION are becoming clear. She does not mind revisiting familiar images: one is the secluded garden hedge; another, the small object in the grip of a crystal (the birchbark lamb, the splintered phoenix, the floating dandy). This painting is the second essay in near abstraction; it resembles plate 25, but is palpably more beautiful.

The colors are exceptional: leaf-green treetops, set against a muted orange sky. In a bit of brilliant colorism, the artist has chosen a sour brick red for the shadows. And, even more wonderful, the scene is covered with blue hatchmarks and crossed by a network of indigo fissures.

I don't want to speculate whether this really is a soft-focus scene of treetops, or the surface of a rock, or a piece of wood, or even the map of an imaginary country. It is effectively abstract. The artist thinks of it as a window, and the blue, orange, and green spill onto the frame as if they were reflected in a rain-soaked windowsill.

The frame is another serpent; it is nearly abstract, but we have learned to recognize the ominous braid.

How much did this artist know of the motions of her own mind? Did she feel the same thrill at abstraction? I think she did: each time she decided to stop while a painting still made no sense, it must have forced on her the awareness of meaninglessness, and the joy of not playing the game of painting. I am sure she knew how far she strayed from Catholicism, following the allure of esoteric learning. She must have known, too, how utterly inexplicable some of her visions would be, even to her alchemical friends. (Alchemists, who prided themselves on their eccentricity, were often stolid and mechanical when it came to pictures and symbols. This work is far beyond their reach.) I think that's why she returns repeatedly to themes of isolation and solitude, and why I find the entire book so much like a diary.

# 35

THESE ARE PLACID RECURRING DREAMS, where a few figures gather in some garden alcove or private hedge. This time it is Venus and Cupid. She is tubby and middle-aged, with a stocky torso and small, sagging breasts. (This artist doesn't flinch. In that she is like Rembrandt, who was always interested in the truth of the matter.) Venus's little head looks powdered and shaved, and her long hair is disheveled. She holds Cupid's hand, but he turns away. His two little wings flutter impatiently.

This is a dull, half-realized scene. I doubt the artist lingered long over it. The outside ring is shapeless and flat, free of the sinister convulsive movements that begin to stir when she looks more carefully. The painting is a matte brown, without the usual iridescent glow. But we shouldn't just brush this painting aside in search of other, more inspired images, because every painting tells us something about the artist. I sense from this how tedious the whole project might have seemed, and how much force of attention it required to pull those images out of the wood.

If I look at something inexpressibly uninteresting, like the cut section of a log, my eye will be rebuffed. Brown wood everywhere!—with nothing to catch the eye, no motion, no color, no curious detail. This painting gives us that state of mind. Luckily, this artist could also wait while the wood slowly came to life. Looking into a dark mass, she would catch sight of a little motion—something in the wood grain itself, a little shifting or optical trick—and she would keep looking, letting it grow into an oscillation, letting the wood begin to bend and undulate, until it finally burst out in the coils of a snake. Colors also begin to flower when the eye is exhausted from the incessant labor of picking over identical browns. A little ochre patch might seem to glow and get brighter, warmer, until it suddenly catches fire and glows a candent yellow.

That is the hard work of prying hallucinations from dull wood. Occasionally, the mind is just not up to it, and the world stays flat and insipid.

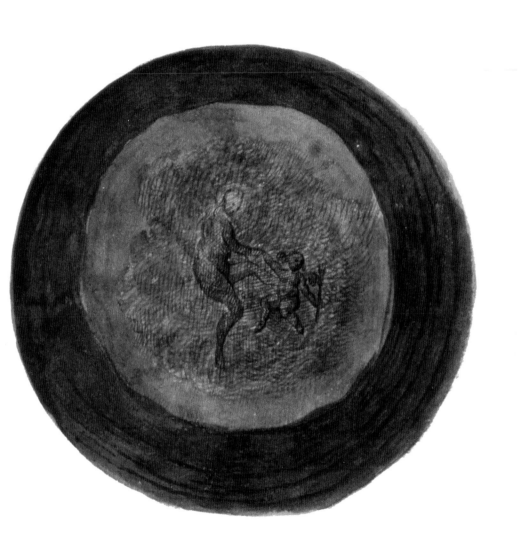

# 36

TREES AND PEOPLE ARE MINGLED from the very beginning. There is a story that a tree sprang from Adam's grave, and the wood of the cross was made from it. Adam's body, rotted, provided the material for the crucifixion. In his lifetime, Adam must have spent a great deal of time thinking about trees, and one in particular. In the Middle Ages people painted the Tree of Life, the Tree of Salvation, and the Tree of Jesse—symbolic trees whose branches exhibit Christian doctrine. Thoughts like these may well have been swimming in the artist's head. Her decision to paint wood could have been a personal secret, but the meaning of wood was not. It was inevitably the wood of the cross and the Savior—the descendant of the Tree of Jesse, the staff of salvation.

But the artist's imagination is too wayward to allow her anything as obvious as a Tree of Good and Evil. This is a vision, bursting from the sky: a man appears in a cloud of leaves and branches. The branches tremble, and there are feathery green afterimages all around. Is this God in the burning bush (burning with a faint green fire)? Is he a prophet? Jesus himself? Or a male form of a dryad, the ancient spirit of some tree just glimpsed between the leaves? He spreads his arms as if he were the crucified Christ, but he does not look the part, and his cross is in full bloom.

All is not well with this apparition. He has no hands: they do not exactly merge into the branches—they just disappear. It looks as though he has a thick collar, but it turns out to be a set of coils, as if he were being squeezed by a boa constrictor. His body twirls and descends into a slender trunk. Purplish coils unwind to either side of his waist, like the spiral stingers of a jellyfish.

What *is* he? And what is happening to him? Is he pulling himself out of the wood itself? Or is he crying out because the tree is pulling him back into its branches, sucking him down into its roots? This is not a Christian vision, and not a comforting one. As Carl Jung said, Christianity was too close, too disturbing for alchemists to take at face value. They tinkered with it, and sometimes they produced monsters.

All this against a rosy evening sky, with a snake wandering lazily up one side.

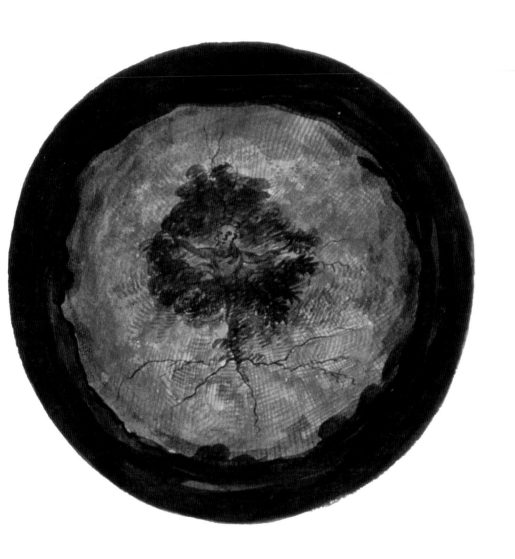

# 37

ANOTHER WEAK PICTURE, made with very little energy. Two Ottoman kings are taking their leisure in a grove of trees. The one on the left is older, and stands delicately with his feet together, resting on his staff. His companion is younger—perhaps forty—and cuts a more elegant figure. He wears a light-colored sash and sandals that lace up to his knees. His hand is decorously draped over his walking stick.

They pause, of course, in front of a cave. In this book the world is seen through the wrong end of a telescope, or through one of those fish-eye security lenses. We are in the dark, by ourselves, and we look at the world from far away. I think we are often invisible: people pause by the entrance to our cave, but then they go on their way.

Or perhaps these are not caves at all, but holes in trees. In that case all these paintings are views from the inside of trees, looking out at different times and places. Like a worm, we can crawl anywhere underground, or through the soft wood, and peer out at the world. Some of the holes may be little openings in the dirt, like the tunnels used by snakes, or the minuscule holes earthworms make in every inch of the ground. (They are everywhere, like little eyes in the earth.) Perhaps this is a book painted by a worm, or by many worms.

The unremitting loneliness of these paintings leads me to these thoughts. On the one hand, they are probably more macabre than anything the artist intended; on the other hand, hers is not an ordinary isolation. She is so far away from the world that things begin to look strange, and she can't quite tell what is happening. She can no longer hear, or understand. (What are these Ottoman kings saying? Where are they going?) Shapes and colors are mutable: a lamb may become a cloud, or a larva may grow a red beard.

This is the price—the huge price—for seeing such stunning visions. The challenge is to court madness, and if you fall in, to be sure you can climb back out.

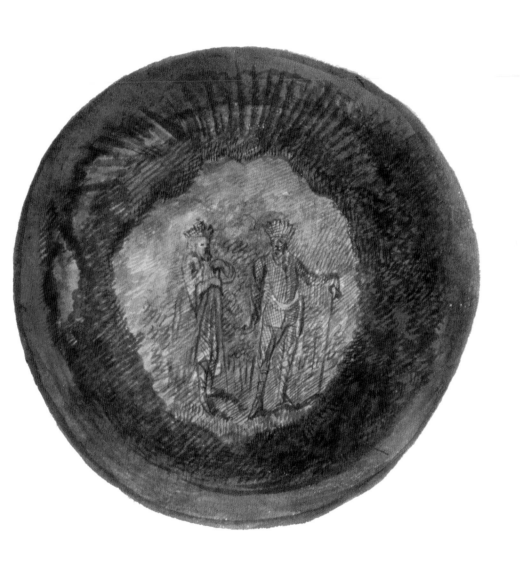

# 38

IN THIS FRAME OF MIND, ANYTHING IS A SOLACE.

What if, walking along at night, in a snowstorm, you came upon this man? He has a huge purple coat, the color of the night, and a turban pinned with a helical spike. His Chinese collar is neatly fastened, and his arms are at his sides. He smiles, but his eyes are disjointed balls, and they hang at odd angles. A white sphere, like a seer's crystal or a snowball, hovers in front of his lapel. Around him two snakes lay their tails on one another and kiss.

I assume you would be frightened—he is certainly an evil sign. At the very least he is a sorcerer, and a token of bad things to come. In the seventeenth century, people would have said he was an Oriental magus—meaning a man conversant with Hermetic secrets and dubious medicines.

But in this artist's frame of mind, he may also be a welcome sight. She has spent so long among shifting and unstable images that it's a great comfort when anything can be given a name. What is really frightening is when the world ceases to make sense, and pictures begin to form themselves without rhyme or reason. In comparison with that, this is just a garden-variety scare.

It is tremendously difficult to avoid meaning, but that's what I look for in pictures. If this manuscript had been full of paintings like this one, it would have been a tarot deck, and I would not have written about it.

If the artist had been one of my students, I would have told her that this painting is too easy, and she should return to her thicker imagination.

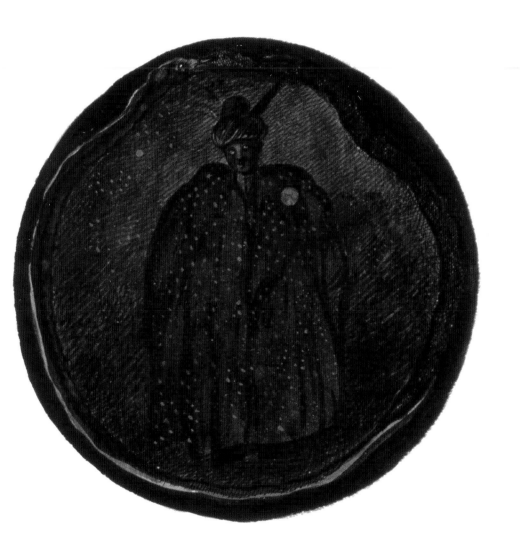

# 39

SEVEN MEN PUT A LONG SPEAR UP A DONKEY'S ASS. A moment ago, the donkey was sitting peaceably, and now it pricks up its ears in alarm. Its mouth is open—I imagine it braying in surprise.

The men are dressed for an outing, with feathers in their hats. One figure, the largest, may be smiling (he looks like he has shut his eye in glee), yet the picture doesn't seem especially funny. The other figures have the expressionless faces and workaday attitudes that figures often have in emblems, where their only purpose is to set up the moral. If this were a proper emblem, it would have a caption explaining the image and drawing some pole-faced lesson: something like "The wise ass watches his tail."

Perhaps the painting is a pun (on a word for "ass"), or an allusion to an old folktale. One German viewer said it reminded him of an old Swabian story in which six men impale a boar—but he couldn't remember anything further. It may also be a scene from a low comedy, with some obscene punchline.

But there is no explanation, no folktale, and no pun. That is the joy of this painter: she may well have had no story in mind at all. She would have known that viewers would ransack their memories for some explanation, and even try to have a little fun thinking up punchlines; and she would have known that pictures lose interest each time something is explained. First she saw a crack in the wood, with a rotted hole at one end. A few minutes later, the crack became a ramrod, and the hole turned into an unexpectedly placid donkey. That is what needs explanation, not the story that may have been floating in her mind.

As she paints, she becomes more literal about her snakes. The twinned green serpents in this painting are the first with scales, and the mud-gray snake is the first with an articulated eye. They are visibly less evil than the fugitive wormlike shapes in the earlier paintings. Perhaps the game is playing out, and the specters she wrestled with early on are becoming domesticated.

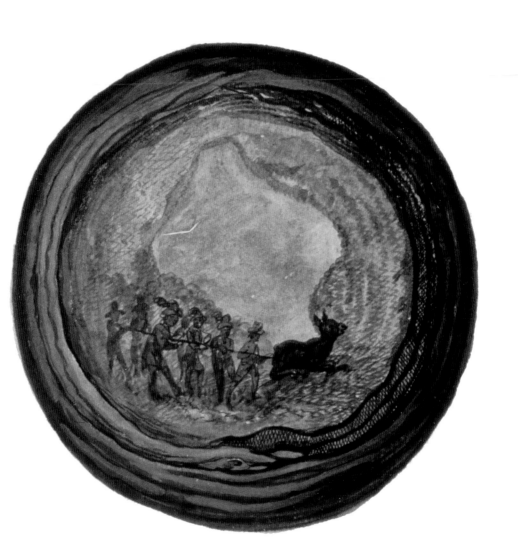

# 40

A BENEVOLENT KING AND QUEEN, on their garden thrones. He leans back impassively, his eyes shut and his pointed beard thrust forward. One hand delicately holds a thin scepter, and the other is comfortably folded in his robe.

He is about to be stirred from his regal reverie by the queen, who waves to us with one hand and reaches for him with the other. She is wearing a voluminous flounced dress and upturned veil.

The scene could be taken from any artist's memory book, and nothing would distinguish it from an ordinary pale fantasy except its supernatural glow. Brown crepuscular rays stream out below the royal pair, raising green ripples as they go. Above the king and queen three green rays go shooting up like dark searchlights. (Occasionally at dusk there are such phenomena; they are called "sun pillars.") The air vibrates with leaves and currents. Most beautifully, white streamers cross by up above, like auroral bands or the reflections that bright waves send up onto a shadowed wall.

The king and queen are enthroned in spectral glory. Two centuries later, the apparitions around them would be called "auras," and studied by pseudoscientists (and later, by abstract painters such as Kandinsky). In her century, this artist was the only one who dared to paint what she could not see.

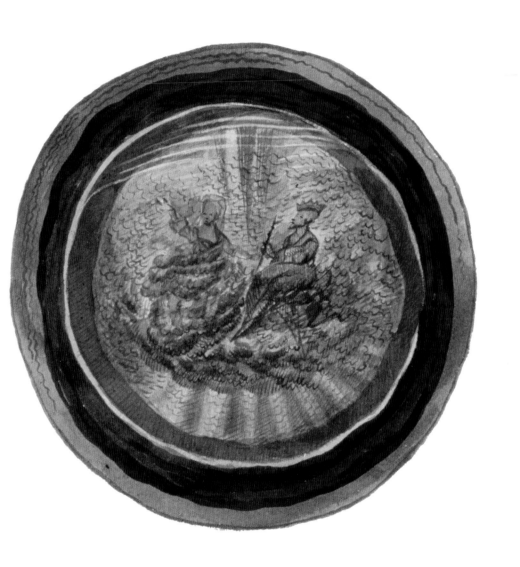

# 41

THIS IS THE RULE FOR AVOIDING MEANING: if you paint a private story, known only to yourself, you can be as explicit as you want; but if you paint a public story, it has to be partly erased. The seven men and the donkey (in plate 39) were as plain as could be, and entirely immune to explanation. This is one of the most famous stories of all, the creation of Adam, painted as it never had been before.

God is a tall Oriental figure in a turban and full-length robe. His face is a bluish shadow. Adam lies naked, looking at his creator. He extends one arm. God is still fashioning him: his right leg is a blur, and his left arm a round stump.

This is not the Garden of Eden. The Creation takes place at a great distance, immersed in a deep stained-glass blue. All around are swarms of muddy little worms. We are in the darkest place, at the root of the maelstrom, and so—I return to this thought once more, still hoping it is not quite true—we are among the damned, a worm like any other, looking out through our swarm to where something holy is taking place. We may be the Serpent himself, waiting off in some crevice while God makes Adam, Eve, and the rest of the Garden.

I am not good at stopping myself from finding meaning, and I think no one resists it for very long. As far as pictures go, a neat, determinate meaning is the ultimate temptation. But I try to watch myself, and check the urge to label and explain before my explanations have wholly won me over. This *could* be the snake's-eye view of the Creation, but it might also be something significantly stranger. It is usually a good test to imagine how a painting was made: in this case the two figures were the work of a minute or two, but the worms took much longer. Some of them are painted in opaque white, meaning that the dark layers beneath had to dry. The painting must have been evolving, growing worms, for several hours at least. Worms are its subject, and the distance between them and the Creation is the same as the distance between this picture and its explanation: it cannot be bridged.

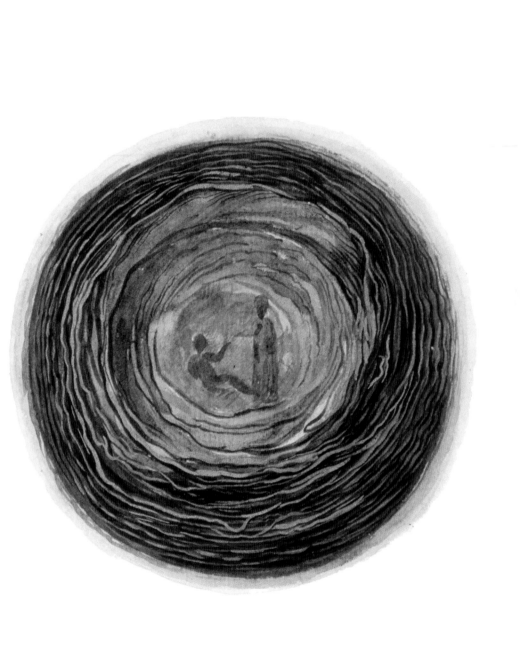

# 42

NOTHER GROUPING, ANOTHER STORY THAT WILL NEVER BE EX-
PLAINED. An angel with the neatly trimmed hair of a young girl
stands in shadow. A bit of her garment flutters behind her in typ-
ical angel fashion.

Next to her is an old Oriental king, a benevolent figure in this artist's
mind. He crosses his arms piously. Then comes a younger king, who bows
slightly, and a musician in a flat-topped cap.

They could be the three Magi, if the musician is another king. Of course,
it's broad daylight in their little heart-shaped hole, and that doesn't fit the
story.

The angel is not the one in the Gospels. Her legs face away from us, but
her torso faces front. She has one left arm and one right wing. Her garment is
a bit odd, and she may be carrying something—or she may be several angels
partly fused.

These dislocations are powerful attractors: having seen this picture, I will
always think of it when I see the hackneyed scenes where the typical angel
points to the inevitable stable. For me, the kings are forever swimming in a
milky cavity, encased by hard gray stone with rusty patches and fine-grained
cracks.

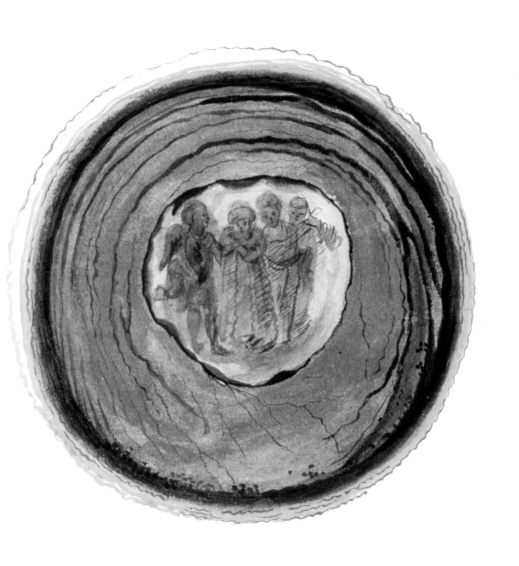

# 43

THIS PICTURE IS LIKE THE GHOST OF A REMBRANDT. The subject is a scruffy, middle-aged man, of no particular good looks, wearing an artist's beret (the kind Rembrandt affected) and an ostentatiously false bit of costume jewelry (which Rembrandt also liked). He stands, or sits, in an umber gloom, just as Rembrandt preferred. Since things are so murky, the jewelry may be the hilt of a sword, a staff, a necklace, or some medallion: it does not matter much more than it mattered to Rembrandt.

But think of all the things it does wrong, and all the ways it could never be a Rembrandt. It is not a portrait, since the artist has virtually no interest in expressions or psychology. (She almost doesn't see faces, and never gives them more than a few quick brushstrokes.) The darkness is not relieved by a shaft of light or a dab of rich paint. In painters' terms, this is only an underpainting, still drab and rough. And—we shouldn't forget—the figure is almost lost in its setting, a harshly painted blue-and-black crescent and a few golden rings. Over the course of this manuscript those rings have seemed to mean many things—snakes, worms, caves, bark, the circles on round maps, tunnels, window frames, panoramic landscapes, the borders of coins—but what they mean best, and mean most powerfully, is that these are not normal pictures. The rings are like a rubber stamp that says VOID: no matter what the artist paints, it cannot be what it seems to be.

# 44

ACT ONE, SCENE TWO IN THE LOW COMEDY THAT BEGAN in plate 30. The first scene was a ribald one, with plenty of big laughs and off-color humor. I think it was too much—not because it was rude, but because it was too obviously a story. It even had a dramatis personae: Atlas, Hercules, and Mercury in stage rear, three delicious deerlike nymphs at stage front.

When her imagination revisits the scene, things have become much less certain.

The three men have become as shadowy as the women, and they have lost their names. One on the left holds up a bow, and has an arrow in his other hand. Among the gods, Apollo was an archer, but it no longer seems to matter. Opposite him another man holds a wobbly sword, and above them is a figure naked except for a loincloth. They are purplish ghosts, instead of the overweight posers in the earlier painting.

The women are even more elusive. Two sit holding hands. They are only women by virtue of stray bits of hair. A turnip-shaped shadow on the left may be the head of another (sister to the dog-woman in the other painting).

In short, it's an echo of a memory of the old sex comedy. And look at what's happening in the air! The space between the two women is filled with rosy light, speckled with red-brown spots like little spiders on an iridescent web. The scintillating air streams up and fills the sky outside the cave, throwing a veil of pink over the blue. The artist has salted the sky with golden flecks, like the dabs of gold paint or leaf that make medieval paintings glitter. The hillside is lemony and green, and a stream slides down inside the cave, reflecting blue, ochre, and gray. Colors have never had any meaning, much as people have tried to foist meaning on them. They say nothing in themselves, and they steal meaning from everything they cover.

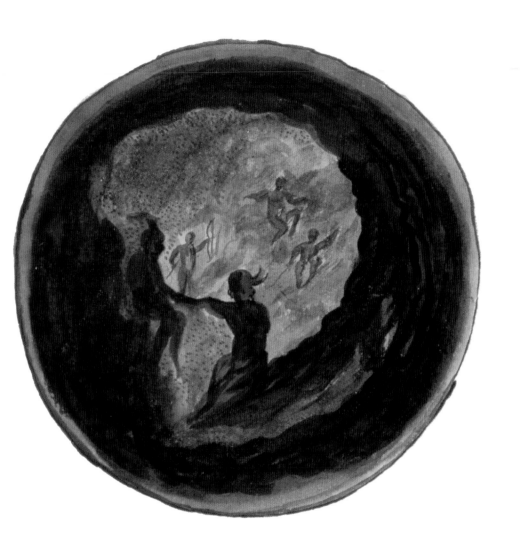

# 45

ANOTHER MYSTERY REVISITED, this time the three old men of plate 10, and the three kings of plate 42. Those references are necessary: I think the viewer is expected to start leafing back and forth, trying to find themes, looking to tie up loose ends. But these are dreams or daydreams, and they do not come to conclusions. If I dream of my father, I always dream of my father. Characters age, and hide, and put on different clothes, but I know who is there. These are the three Magi from plate 42, and the three self–portraits from plate 10. One swims in the clouds, one points dramatically with a needle-sharp finger (and a beard just as sharp), and the third leans back, regal but abashed, resting a gloved fist on a large sack. Two little angels—putti, in the painter's language—support him, and another looks down from above.

These dramas have no fixed shape in the artist's mind. This time everything is argument and expostulation, and theatrical gesture. If she painted it again, I would start looking for Oedipal problems (the son challenges the father, the father flees in dismay). But it's all just operatic posing, the kind that happens in any dream when the mind is full of unexpended motion. Thoughts bubble to the surface, her hand tries out a figure, and the composition takes shape even if it doesn't add up to much of anything.

Still, I don't think Freud would be so sanguine about it. He would say a dream without a story is a dream we do not yet understand. The artist may not be telling a story here, but by that very fact she is avoiding a story. There is nothing, in the end, but stories, and the urge to ruin them—which I have been celebrating, and calling modern—is also the desire to avoid them. These are smothered stories, and they compel attention because we can sense the asphyxiation of something underneath.

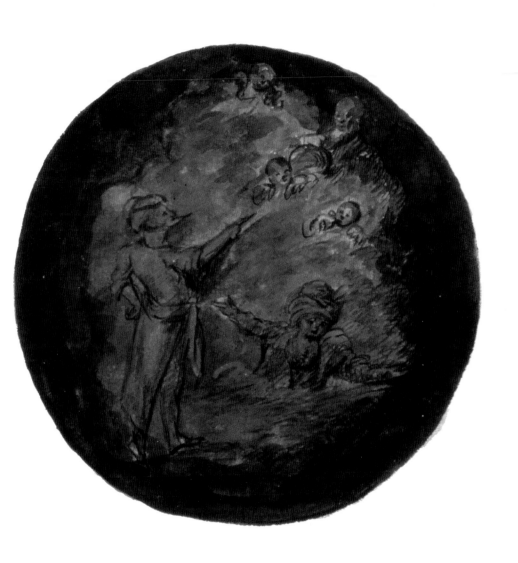

# 46

AT THE SAME TIME, I DON'T WANT TO KNOW what the story was. Unlike Freud, I do not like stories, and I don't trust them. (I mean, in paintings: a written story is entirely different.) Freud might have been especially interested in this painting, where a young man in military dress, with unsheathed sword, rushes at a naked woman. He steps between her legs and points at her, and she holds a hand in front of her face. The man may only be trying to help her—his step is somewhat dainty, and she may already have been crying—but he may intend to rape her: that was common enough in Baroque pictures. Either way, the scene is explosive and violent, out of character with the rest of the manuscript. Even by this artist's standards the lump at the top is particularly sinister: it looks like a face, but the shadows are too dense to tell. Mossy tendrils hang down from the cave's mouth, converging on the central encounter.

A psychoanalytically inclined viewer would be sorely tempted to say this is one of the truly disturbing stories that the artist's happier pictures serve to hide. If a woman painted the manuscript, then this scene is especially fraught, and it would bring to mind other Baroque examples of women painters who were mistreated, and found themselves drawn to certain kinds of sexual imagery.

Of course we may never know. But let us say that the artist is someday identified, that her life story is discovered, and that it turns out she was once raped. Then this painting would definitely be about her life, no matter how she disguised it, and her other paintings would be seen in its light. The old men would be father figures, more or less, and the scenes of solitude would be expressions of her resentment, or her hope. (Artemisia Gentileschi, one of the best-known women artists of the Baroque, was raped, and her paintings seem to be echoes and memories of her experience.) The manuscript would begin to vibrate with half-hidden autobiography, and even the oddest paintings would suddenly seem to have a point.

This is what I would say to that, and what I tend to say in actual cases: the stories aren't interesting. I am content that we do not know anything about this artist. What compels my attention is the little island inhabited by the two figures, the rain trickling down (if that is what it is), and the rippling water in front (if that is what it is). I love the black cave and the unraveled string that ties it, and I especially love the keystone, with its ponderous froggy chin.

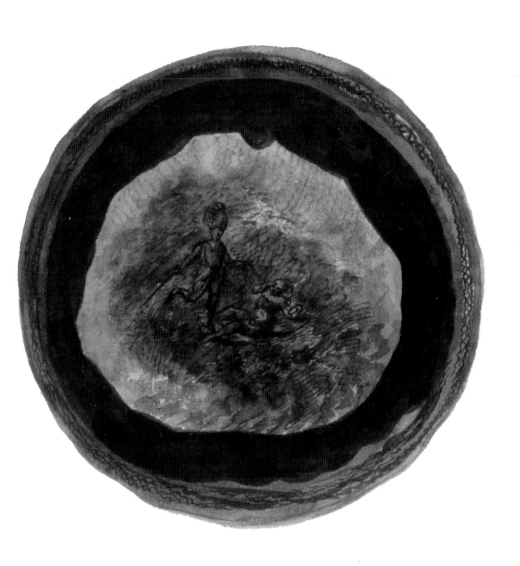

# 47

I'M HAPPY WITH PICTURES THAT DON'T TRY TO TELL ME WHAT THEY MEAN, especially when they don't know themselves. This painter could have told many stories: she knew how to compose scenes of nobility and aristocracy, or peasants and their farms; how to paint God with a crowd of saints, the Three Kings at the Nativity, and even the Fall of the Rebel Angels; how to whip up a good mythological painting with Hercules, Mercury, or a set of nymphs; and how to be a good alchemist and treat us to a parade of stock symbols—the ouroboros, the crowned lion, the hermaphrodite.

Sometimes she almost does. But then her imagination carries her off a little, like a wave shifting the sand under our feet. She ends up a short distance from where she was, and the story gets slurred. I think she cherishes that little motion that ruins the game of storytelling, and sometimes she watches as her images go on blurring and shifting until almost nothing remains.

A few paintings give up nearly everything. This is one of the simplest and purest landscapes painted before the later nineteenth century. In the Baroque, landscapes usually had to be embellished with lively details: a man struggling with a heavy cart, a sleeping nymph, a hunter returning with his catch of pheasants. This has almost nothing—a cave, two trees, and a mudbank. There is no comforting steeple in the distance, no bird overhead, no wandering hermit or stray dog to help us find our way.

The artist is an expert on caves, sumps, hollows, and wells. This particular kind of cave, where the land just collapses into a deep hole, is not uncommon: some appear bottomless, and others are choked with dirt or littered with the bones of animals who have fallen in. We are down there, deep in the earth, looking out and up at a world that we do not inhabit. What kind of story could possibly fit here? What is there to do but look? The green sky vibrates, and crackles with dark olive lightning. A single bolt drops silently down, touching the tree but not harming it.

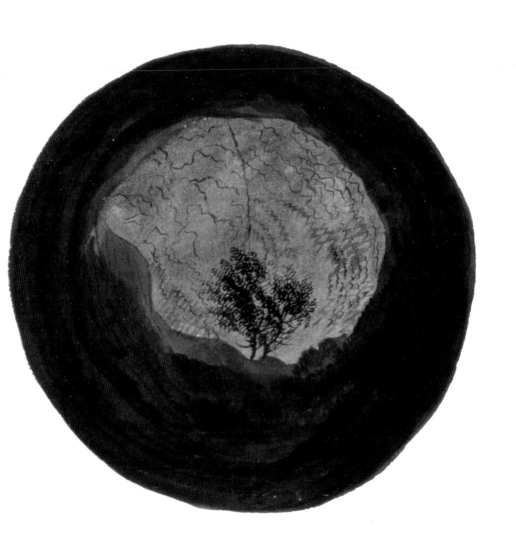

# 48

NOW WE ARE MOVING EVEN FARTHER AWAY, down into the cave, back into the tunnel. Far off, almost out of sight, a man sits with two children under a small tree.

This artist is in love with distance. She never paints close-ups, and in her mind things naturally tend to recede and grow indistinct. If she hadn't painted this little group, they would have continued to wither and drift until they vanished under washes of brown watercolor, or became flecks of paint in the distance. I think this happens inadvertently, without her understanding or control. If you close your eyes and try to watch a bright afterimage, it will slide away; some artists see the world this way, as if images are slippery and can't quite be kept in hand. Alberto Giacometti had that problem when he painted portraits: he tried hard to keep his figures centered on his canvases, but they kept slipping.

Still, Giacometti tried to fix his images; this artist lets them go. In her mind people are already at a distance, and they tend to fall away from her unless she makes an effort to reel them in. I think that falling or fading gives her pleasure, and many of these paintings are consolations: people—and gods, and God himself—are off at a distance, where they can't quite be heard and can scarcely be seen.

Only two things give her more pleasure: abandoned places, where no figure crosses the mind's eye; and crystals that hold pieces of the world in perfect suspension. This painting has a little of the crystalline about it: the miniature vignette is like a carved shell, or a precious gem clasped in a cracked and ancient setting. In the tunnel pictures life is still present, but it is slipping away; in the crystalline pictures everything is fixed, and also dead.

I know these feelings because I share them: I am aware that my interest in partly meaningless pictures goes hand in hand with an affinity for ghosts. Although I said at the beginning that I was interested in this manuscript because it avoids conventional sense, I am also a bit spellbound by its strategies for avoiding obvious human dramas. I love the skewed eye and what it does to the things it sees. That is the reason I choose to think of the artist as a woman: if I didn't, things would be too familiar.

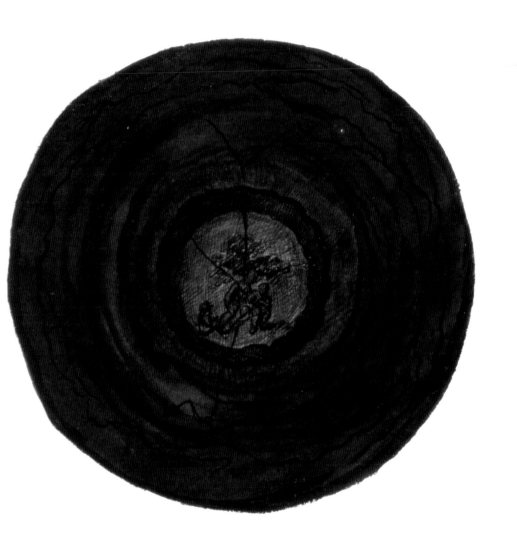

# 49

WHEN IT IS TIME TO LEAVE, the direction to go is out, and up. It would have been fitting if this were the last painting in the series, because it would mean there is some way out. (But out to where? And back to what?) The figure—whom I take to be a guide—looks down at us and gestures upward. If we were to follow him, we might leave all this behind.

But could we? He is walking in the air, balancing on a trembling lightning bolt as if it were a piece of string. The sky he is climbing is especially dense with electrostatic charge. Before we could even get to him, we would have to step over a huge snake, and it is already eyeing us unhappily. And this is no ordinary guide: he is steel gray, and he is missing both feet and his right hand.

In alchemical books there are pictures of people who walk without feet: they represent the final stages of the alchemist's quest, when he is nearly fixed in place (stability is the ultimate idea, to be as immutable as gold) but still needs to move just a little farther. This is not the kind of guide we can follow. He is showing us something that we cannot copy—the trick of walking without feet, on threads of lightning. This is the "pneumo-cosmic" nature, breathing and moving, dangerous and tantalizing, immediately at hand and utterly inaccessible.

There are two kinds of loss in this book, and they are intimately entangled. There is the loss of human contact, and the loss of meaning. They express one another: when it seems that people have drifted off, then their stories and sounds also become faint, and the pictures lose meaning; and in a complementary fashion, when the pictures fail to make sense, they lose their reference points in ordinary human actions. It is a double loss: meaning empties out through two drains. The rings of bark and decaying wood of the tree trunks gave her many opportunities to reflect on distance, and to discover how far she wanted to be from people or from meaning.

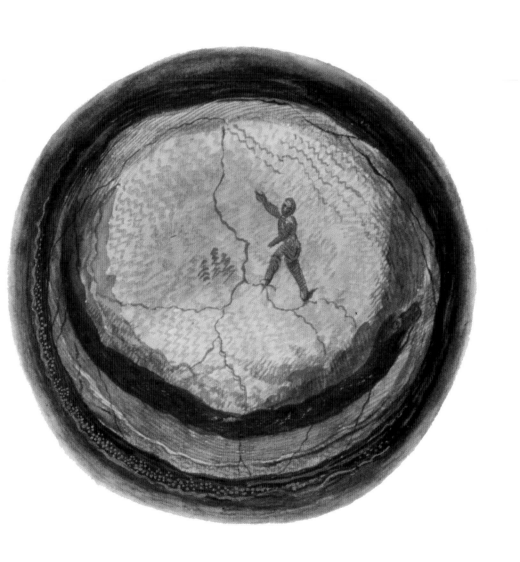

# 50

THIS BOOK IS LIKE A SILENT DIARY. Sometimes the artist spends time thinking seriously about a specific problem: in the opening sequence she explores heaven, and decides it is haunted by flimsy ghosts; later she thinks about how the world was created, and finds it ends in evil (plates 19 through 23). For the most part, and especially in the second half of the book (from plate 24 to the end), there are fewer questions, and the themes come and go like the daily preoccupations in a diary. Most diaries break off when the world becomes more interesting or pressing than the exercise of describing it. I think the artist set out intending to produce a good Aristotelian drama, with a beginning (the creation of the world), middle, and end, but she let her ambitions go as the flood of images carried them away.

That kind of open-endedness is anathema to scholars. Several art historians who have seen the book thought it must be unfinished, or fallen out of its proper order. Others have said it is the work of an apprentice or a dabbler who lacked the skill to pull a story together. By deep habit, historians search for sequences and dramatic endings. A work without a conclusion is nearly insufferable: years ago I had a teacher who dreamed he found the lost ending to the *Faerie Queene*, and Umberto Eco's novel *The Name of the Rose* is an elaborate fantasy about the lost part of Aristotle's *Poetics*. But what if this manuscript is finished, in exactly the way the artist intended? What if she set out, as it were, to paint an indeterminate number of paintings, and to stop when she lost interest?

I believe that is what happened. This is a diary in the sense that it conforms to a simple rule: it fills every page, and it fills them in order. A diary, in this respect, is just another way to avoid telling a proper story: like a part of life, it goes on for a while and then ends. A diary is not an exercise in randomness or nonsense, or an opportunity to be wholly meaningless. Diaries follow the contours of daily thoughts, from relative clarity to disaster, from the dangerously deranged to the entirely universal. They can loop back on previous thoughts, and even contradict themselves—as when the artist's almost Epicurean musings on the absence of a Christian God give way to this elegant and entirely acceptable Pietà.

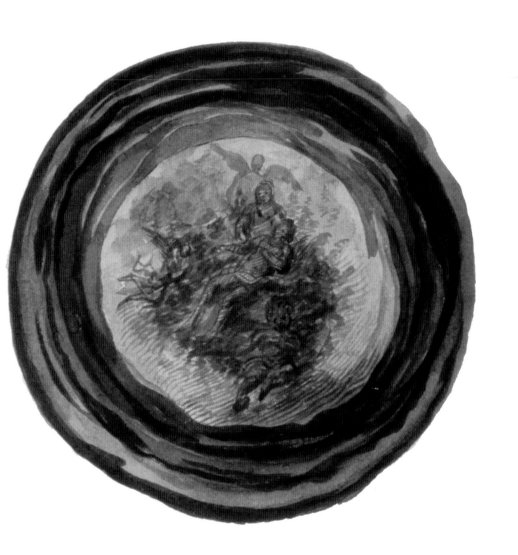

# 51

I ADMIRE THESE PAINTINGS FOR ALL THE WAYS THEY FAIL TO MAKE SENSE, and so I also admire how the series winds down. It must have slowly lost the artist's attention, and I imagine her interest began to turn to other things about now. Of all the brilliant things she does, refusing a proper ending is the most audacious. The pressure to end a story is almost overwhelming: I am caught up in it myself, trying to bring this book to a conclusion. She was more honest and attentive, and followed what she saw.

This penultimate picture is another scene half-assembled from her stock of figures; each is changed but still the same. In the middle is an Oriental king; we have also encountered him as an adept of the Hermetic arts. The snowball he once conjured (in plate 38) has become a globe, symbol of worldly knowledge. His sidekick, the paunchy second king, is with him again, this time reeling in surprise. The third figure might make a set of Magi, or he might be one of those young soldiers who run in and out of the paintings.

Notice how gentle the artist is with the people in her imagination: she doesn't force them to play the three Magi, or anything else. Nothing is unwelcome, unless she recognizes it. As she made the paintings, the figures would have looked increasingly familiar, and I would like to think she lost interest in her project when she began to feel at home in the contours of her imagination.

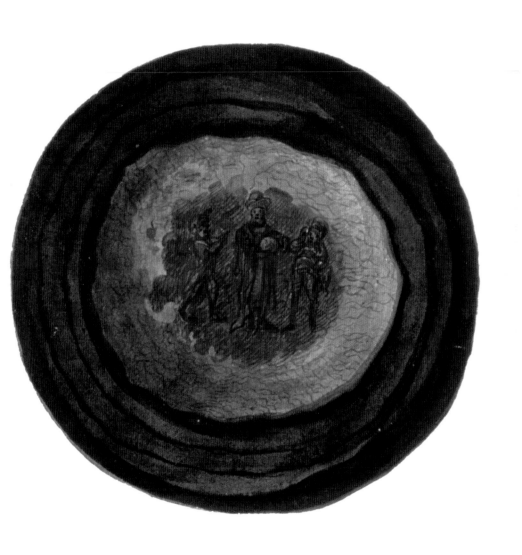

# 52

THIS IS THE WAGER I HAVE IN MIND: that these paintings—some of them, the best, certainly not all—will have a grip on the imagination not easy to loosen. After living with pictures like these, it will be hard to go back to the Madonnas and Children, the Herculeses, the Venuses and Adonises who say what they mean and mean what they say. Pictures with titles will seem too easy, too obvious. Pictures with messages will seem misguided.

Clearly, paintings exist, in part, in order not to make sense. This anonymous late seventeenth-century artist is not modern in the sense that she fits in with Man Ray or Max Ernst; she is modern in the ways she occludes the clear subjects that she might have painted. If that means making God the Father into a green specter, or stretching a lamb into a dome and pasting on a puppy's head, she does it. The only limit is what she can bear to see on the page.

We are attracted to paintings before we know what they are supposed to mean, and I think their wordlessness continues to draw us toward them, even though we often forget it in our rush to find their sense and purpose. People who write about art can be uneasy about this: they know they are fascinated by the parts that don't make sense, but they also feel the pull of meaning. There is a good reason, in the end, why I will lose this wager: every painting has its quotient of wordlessness, and the titles and narratives of major paintings can often be understood as decoys—as the expected tags that ostentatiously fail to explain much of anything. Still, there are certain frames of mind in which it is essential to see that a painter knows pictures are not texts, and this manuscript answers that need as well as any artwork I know.

In this final scene, a naked young woman sits on the familiar garden bench. She has just turned to see something that is outside the picture. A few yards away a young man is sitting quietly, looking up into a cloudy sky. They could have had names, and they could have been looking at each other or at us. They don't, and there is no reason why they don't. We might have been told what each of them sees, or what they think. We will never know. That is the pure pleasure of this painting.

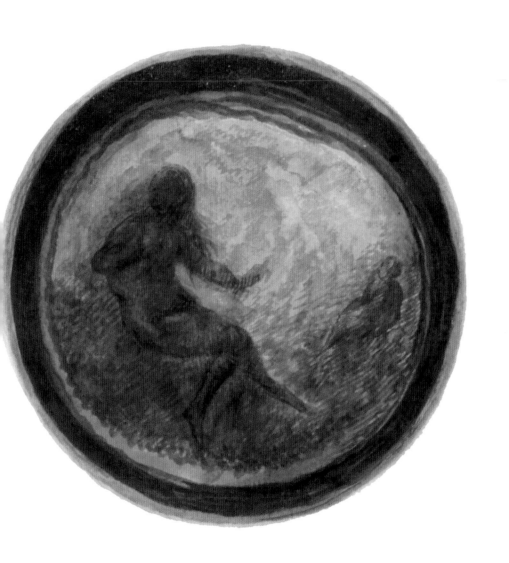

# POSTSCRIPT:
# FALLS FROM FAITH
# IN THE
# SEVENTEENTH
# CENTURY

The unknown artist was *almost* alone in her weird distortions, but not quite. Just a few passages of sevententh-century poetry and prose rise to her level of radical metamorphosis. Among them my favorite is from *Paradise Lost*, a book she might well have known if she was—as one historian told me—an English painter:

> The other shape,
> If shape it might be called that shape had none
> Distinguishable in member, joint, or limb,
> Or substance might be called that shadow seemed,
> For each seemed either; black he stood as night,
> Fierce as ten Furies, terrible as hell,
> And shook a deadly dart; what seemed his head
> The likeness of a kingly crown had on.
> (2.666–73)

This is Milton's description of Death, and it is very close to this artist's uncanny combination of formless fantasies and whimsical costume dramas. (Imagine: a deep black cloud with a crown.) Milton is appropriate here, because he has also been read as a poet with a deep loss of faith in hell and Satan. He choreographs his Satan, keeping control of him like a puppet on strings, and that has struck modern readers as evidence that he thought of hell in some measure as a poetic trope, just as his model Dante had done. It may be, as Lucien Lefebvre has argued, that atheism was intellectually impossible in the Renaissance; but deep, nagging skepticism was not, and neither was alienation—and yet those words are too harsh, too modern and confident, to capture what happens in this book. There is a childlike playfulness here, and a dreamy hope that pagan and Christian deities might inhabit a spectral landscape alongside aristocrats, fuzzy monsters, and fun-house apparitions. It is a delicate frame of mind, not

as confident as atheism or as corrosive as pessimism. And its delicacy is of a kind that only pictures can have.

But we will probably never know what she had in mind. It is part of the world's richness, which I put against the dull uniformity of the commercialized world, that manuscripts like this still sit, unseen and unread, in so many libraries. And it is especially wonderful that even when her book is seen again, it refuses, in the end, to speak.

# DISCUSSIONS ON THE INTERNET

In the fall of 2011, I posted parts of this manuscript online, looking for more ideas. Here are some of the comments I received, with the commenters' names in parentheses.

*Plate 1.* This first image elicited a barrage of technical art terms, which weigh heavily on the side of sense and logic, against the image's mystery. It is reminiscent of late Baroque frames, one person wrote—the kind where stucco was used to create billowing cartouches around paintings (Filip Lipinski). Or it could be understood as a *quadro riportato*, the painted representation of a framed painting: in that case the cartouche would be a trompe l'oeil, intended to fool the eye into thinking that the frame is real and the image is not—even though neither is real. That would certainly add to the image's mysterious, life-through-a-telescope look. Or it might be looked at the way one looks into a crystal ball or divining pool, according to the art of "scrying" (Mayra Barraza). In that case we would be attempting to divine something mysterious, just out of the range of normal eyesight. It's difficult, however, to know the extent of the use of crystal balls and scrying pools in the late seventeenth century; they were certainly used in the Renaissance, and they enjoyed a renewed popularity in the late nineteenth century. This painting, like all the others in this book, is an excellent example of *pareidolia*, the divining of significant forms in apparent randomness (Matt Ballou). Or—just to add even more polysyllabic explanations—they could be seen as classic examples of *aleamorphs*, forms occurring naturally, and only enhanced by the artist.

*Plate 2.* The rows of yellow clouds could come, ultimately, from Correggio's domes in Parma; but it was also suggested they derive more directly from Albrecht Altdorfer's *Virgin amidst Angels* of about 1525, in the Alte Pinakothek, Munich (Joseph Podlesnik). If that's so, then there's a specifically southern German ambience in the book.

*Plate 7.* It's possible this is a sculptural group, the sort the artist could have seen in churches. The "bishop" figure looks especially statuesque; the "laughing" figure has an "odd rigidity about it, and the figure next to it has a distinct *contrapposto* stance" (Anthony Cervino). There are ceremonial echoes: the figure on the left may not be pointing, but holding his hand over his companion's head; the kneeling figure is reminiscent of paintings of the Adoration of the Magi (Joseph Podlesnik).

# FOR FURTHER READING

There is a great deal of art historical material that could be brought to bear on this manuscript—if it were relevant.

*Title page.* The title transcribed is: "Opera Magiae Naturalis Mirabili Naturae Pneumo-cosmicae pennicillo Efformata / Per artem Naturae Simiam ad ipsum Naturae universalis Cahoticae Prototypon in totidem ectypis adumbrata atque ad perpetuum rei memoriam conservata." See *Oxford Latin Dictionary*, ed. P. G. W. Glare (Oxford: Oxford University Press, 1988), s.v. "ectypus." Mystical representations of people as apes: Robert Fludd, *De Naturae Simia* (Oppenheim, 1618).

*Plate 1.* For Giorgione's Tempest, see Salvatore Settis, *Giorgione's Tempest: Interpreting the Hidden Subject*, trans. Ellen Bianchini (Chicago: University of Chicago Press, 1990).

*Plate 2.* Ceilings like these began with Correggio's *Assumption of the Virgin* in the dome of the Cathedral of Parma, Italy, finished in 1530.

*Plate 3.* For pagan fantasies, see especially the work of Giovanni Benedetto Castiglione (1609–1664).

*Plate 4.* For Kandinsky's figures, see Rose-Carol Washton Long, *Kandinsky: The Development of an Abstract Style* (Oxford: Clarendon Press, 1980).

*Plate 5.* For garden follies of this sort, see my "On the Conceptual Analysis of Gardens," *Journal of Garden History* 13, no. 4 (1993): 189–98. Another explanation that partly fits this painting is explored, in reference to Giorgione's *Three Philosophers*, in Settis, *Giorgione's Tempest*.

*Plate 6.* For the lack of humor in Western art, see my "Uccello, Duchamp: The Ends of Wit," *Zeitschrift für Aesthetik und allgemeine Kunstwissenschaft* 36 (1991): 199–224. Hallucinatory interpretations are discussed at length in my *Why Are Our Pictures Puzzles?* (New York: Routledge, 1999).

*Plate 7.* Moses's horns: see the discussion and reference in my *The Object Stares Back: On The Nature of Seeing* (New York: Harcourt Brace, 1996). Parmigia-

nino: Claudio Mutti, *Pittura e alchimia: Il linguaggio ermetico del Parmigianino* (Parma: All'Insegna del Veltro, 1978).

*Plate 9.* For modern artists who decline to tell comprehensible stories, see my "On the Impossibility of Stories: The Anti-narrative and Non-narrative Impulse in Modern Painting," *Word and Image* 7, no. 4 (1991): 348–64.

*Plate 10.* For figured stones, see Baltrušaitis, *Aberrations: An Essay on the Legend of Forms*, trans. Richard Miller (Boston: MIT Press, 1989), and Roger Caillois, *The Writing of Stones*, trans. Barbara Bray (Charlottesville: University Press of Virginia, 1985). For Love and Death, see Erwin Panofsky, "*Et in Arcadia ego*: Poussin and the Elegiac Tradition," in *Meaning in the Visual Arts* (Garden City, NY: Doubleday, 1955), 295–320. Similar figures are illustrated in Ulisse Aldrovandi, *Musaeum Metallicum* (Bologna, 1648), and discussed in Horst Bredekamp, *The Lure of Antiquity and the Cult of the Machine: The Kunstkammer and the Evolution of Nature, Art and Technology*, trans. Allison Brown (Princeton, NJ: Markus Wiener, 1995).

*Plate 12.* Hermaphrodites: see my *From Foul Water and Old Stones: How to Speak about Painting, Using the Language of Alchemy*, unpublished MS. Bosch: see my "On the Unimportance of Alchemy in Western Painting," *Konsthistorisk Tidskrift* 61, nos. 1–2 (1992): 21–26.

*Plate 14.* Early lenses: see Arthur Wheelock, *Perspective, Optics, and Delft Artists around 1650* (New York: Garland Press, 1977). Conical anamorphoses: see my *The Poetics of Perspective* (Ithaca, NY: Cornell University Press, 1994). Early microscopes: see my "On Visual Desperation and the Bodies of Protozoa," *Representations* no. 40 (Autumn 1992): 33–56. Convex mirrors: see my "Das Nüsslein beisset auf, ihr Künstler! Curvilinear Perspective in Seventeenth-Century Dutch Art," *Oud Holland* 102, no. 4 (1988): 257–76.

*Plate 17.* Alchemical books in roundels: Johann Conrad Barchusen, "De Alchimia vel Chrysopoeia," in *Elementa Chemiae* (Leiden, 1718), 481–519; alchemical books without words: *Mutus Liber* (La Rochelle, 1677).

*Plate 18.* Emblems and hieroglyphs: see my *The Domain of Images* (Ithaca, NY: Cornell University Press, 1999).

*Plate 21.* Line from the poem: James Agee, "Rapid Transit," *Forum and Century* 97, no. 2 (February 1937): 115.

*Plate 22.* The hermaphroditic guide for alchemists: Carl Jung, *Psychology and Alchemy*, Collected Works, vol. 12, 2nd ed., ed. and trans. Gerhard Adler and R. F. C. Hull (Princeton, NJ: Princeton University Press, 1968).

*Plate 25.* Ceiling painting: Svetlana Alpers and Michael Baxandall, *Tiepolo and the Pictorial Intelligence* (New Haven, CT: Yale University Press, 1994); Ingrid Sjöström, *Quadratura: Studies in Italian Ceiling Painting* (Stockholm: Almqvist & Wiksell, 1978).

*Plate 26.* Farmyard scenes and the *bamboccianti*: Giuliano Briganti, *The Bamboccianti: The Painters of Everyday Life in Seventeenth Century Rome* (Florence: Banco di Santo Spirito, 1983). Goya's dog: Priscilla E. Muller, *Goya's "Black" Paintings: Truth and Reason in Light and Liberty* (New York: Hispanic Society of America, 1984).

*Plate 27.* Coats of arms: Arthur Charles Fox-Davies, *A Complete Guide to Heraldry* (London: T. C. & E. C. Jack, 1909). Microcosmic-macrocosmic diagrams: see my *Domain of Images*.

*Plate 28.* Court of Rudolph II: Thomas DaCosta Kaufmann, *The School of Prague* (Chicago: University of Chicago Press, 1988). Giacometti's portraits are discussed in my *Pictures of the Body: Pain and Metamorphosis* (Stanford, CA: Stanford University Press, 1999).

*Plate 30.* Apuleius, *The Golden Ass*, trans. Sarah Ruden (New Haven: Yale University Press, 2011).

*Plate 36.* Tree of Life, etc.: Carl Jung, *Mysterium Coniunctionis*, Collected Works, vol. 14, 2nd ed. (Princeton, NJ: Princeton University Press, 1970).

*Plate 38.* Hermetic secrets: Brian P. Copenhaver, *The Greek Corpus Hermeticum and the Latin Asclepius in a New English Translation with Notes and Introduction* (Cambridge: Cambridge University Press, 1992).

*Plate 40.* Auras: Annie Besant and C. W. Leadbeater, *Thought-Forms* (London: Theosophical Publishing House, 1901). See also the catalogue *The Spiritual in Art: Abstract Painting, 1890–1985*, ed. Maurice Tuchman (Los Angeles Country Museum of Art/New York: Abbeville, 1986).

*Plate 44.* Color that has no meaning: Stephen Melville, "Color Has Not Yet

Been Named: Objectivity in Deconstruction," in *Deconstruction and the Visual Arts: Art, Media, Architecture*, ed. Peter Brunette and David Wills (Cambridge: Cambridge University Press, 1994), 33–48.

*Plate 45.* Dreams: Sigmund Freud, *The Interpretation of Dreams: The Complete and Definitive Text*, trans. and ed. James Strachey (New York: Basic Books, 1955). For the universality of narrative, see Paul Ricoeur, *Time and Narrative*, 3 vols., trans. Kathleen McLaughlin and David Pellauer (Chicago: University of Chicago Press, 1984–88).

*Plate 46.* Mary Garrard, *Artemisia Gentileschi: The Image of the Female Hero in Italian Baroque Art* (Princeton: Princeton University Press, 1989).

*Plate 47.* Landscapes: Christopher Wood, *Albrecht Altdorfer and the Origins of Landscape*, 2nd ed. (London: Reaktion, 2013), and Creighton Gilbert, "On Subject and Not-subject in Italian Renaissance Pictures," *The Art Bulletin* 34, no. 3 (Sept. 1952): 202–16.

*Plate 48.* Artists who can't keep images: see the account of Giacometti in my *Pictures of the Body*.

*Plate 49.* Footless travelers: H. M. E. de Jong, *Michael Maier's* Atalanta Fugiens*: Sources of an Alchemical Book of Emblems* (Leiden: Brill, 1969).

# INDEX